The Responsibility
of the Artist

THE
RESPONSIBILITY
OF
THE ARTIST

BY JACQUES MARITAIN

GORDIAN PRESS
NEW YORK
1972

Originally Published 1960
Reprinted 1972

Copyright© 1960 by JACQUES MARITAIN
Published by GORDIAN PRESS, INC.
By Arrangement With
CHARLES SCRIBNER'S SONS

Chapter Two was first published under the title "Art for
Art's Sake" in The Critic, copyright© 1958 by Jacques
Maritain

Library of Congress Catalog Card Number — 70-150415
ISBN 87752-145-X

To
WHITNEY J. OATES

Foreword

Foreword

THIS little book is based on six lectures that I was privileged to deliver at Princeton University, under the auspices of the Council of the Humanities, in 1951.

Though the requirements of the subject matter have made it necessary to bring up a number of themes already discussed in *Art and Scholasticism* and in *Creative Intuition in Art and Poetry*, my topic does not pertain to aesthetics alone; it pertains also, and mainly, to moral philosophy.

What are, in the poet, the novelist, the man dedicated to any kind of creative art, the relations between the exigencies of poetry and intellectual creativity and those of moral standards, which have to do with the right use of human free will? What is the moral responsibility of the artist with respect to others, and with respect to himself? While he is striving toward the perfection of his work, is it requested of him, and possible for him, to strive also toward the perfection of his own soul? These problems, which are raised by the very activity of the poet and the artist, and which each must, willy-nilly, solve for himself in one way or another, cannot be treated without reference to aesthetics, of course, but they essentially deal with what might be called the ethics of art.

No questions are more intricate than those which relate neither to Art alone nor to Ethics alone, but to Art and Ethics at the same time. The philosopher who, at the risk

of displeasing everybody, embarks on such questions, must take into account both the dignity and demands of moral life and the dignity and liberty of art and poetry. Have I succeeded in pointing to the kind of balance which, despite the tensions involved, exists between the two worlds I was considering? At least I have tried to do so.

I wish to express my gratitude to Professor Whitney Oates and to the Council of the Humanities, as well as to the Princeton audience, whose generous sympathy greatly encouraged me to publish this essay. I also wish to thank most cordially Mrs. E. B. O. Borgerhoff for the thoughtfulness and understanding with which she assisted me in the preparation of the book.

JACQUES MARITAIN

Princeton, N. J.
January, 1960

CONTENTS

Chapter 1

Art and Morality

I.

DOES it matter what one writes? *What one writes is of no consequence:* this was the motto, some twenty years ago, of those who advocated the so-called "gratuitousness of art." "To be able to think freely," André Gide said after Ernest Renan, "one must be certain that what one writes will be of no consequence."[1] And he went on to say: "The artist is expected to appear after dinner. His function is not to provide food, but intoxication."[2] And again, in a dialogue between himself and an imaginary interlocutor:

> The interlocutor—"Are you interested in moral questions?"
> Gide—"What! The very stuff of our books!"

[1] " 'Pour pouvoir penser librement, dit Renan quelque part, il faut être sûr que ce que l'on écrit ne tirera pas à conséquence.' " *Chroniques de l'Ermitage, Oeuvres complètes*, Paris, NRF, 1933, vol. IV, p. 385.

[2] "C'est après le repas qu'on appelle l'artiste en scène. Sa fonction n'est pas de nourrir, mais de griser." *De l'Importance du Public, Ibid.*, p. 193.

> The interlocutor—"But what is morality, according
> to you?"
> Gide—"A branch of Aesthetics."[1]

Thus the problem of Art and Morality was posed in crude terms. Let us not try to escape the singular harshness of this problem. The fact is that by nature Art and Morality are two autonomous worlds, with no direct and intrinsic subordination between them. There is a subordination, but extrinsic and indirect. It is this extrinsic and indirect subordination which is disregarded both by the anarchistic claim that the artist must be completely irresponsible: *it does not matter what one writes*—then any subordination whatever of art to morality is simply denied—and, at the opposite extreme, by the totalitarian claim that the artist must be completely subservient: *what one writes must be controlled by the state.* Then the fact of the subordination being only extrinsic and indirect is simply denied. In both cases what is disregarded is the fact that the realm of Art and the realm of Morality are two autonomous worlds, but within the unity of the human subject.

2.

Before embarking on a discussion of the realm of Art, I should like to remark that in speaking of Art, we are speaking of Art in the artist, in the soul and creative dynamism

[1] "'Les questions morales vous intéressent?!'—'Comment donc! L'étoffe dont nos livres sont faits!'—'Mais qu'est-ce donc, selon vous, que la morale?'—'*Une dépendance de l'Esthétique.*' *Chroniques de l'Ermitage, Ibid.*, p. 387.

of the artist, or as a particular energy, or vital power, which we have to consider in itself or to disengage in its nature, but which exists within man and which man uses to achieve a good work. He uses not only his hands, but that inner, specific principle of activity which develops in his own soul. According to Aristotle and Thomas Aquinas, Art is a virtue—that is, an innerly developed, undeviating strength—Art is a virtue of the Practical Intellect, that particular virtue of the Practical Intellect which deals with the creation of objects to be made.

But, in contradistinction to Prudence, which is also a perfection of the Practical Intellect, Art is concerned with the good of the work, not with the good of man. The Ancients took pleasure in laying stress on this difference, in their thorough-going comparison between Art and Prudence. If a craftsman contrives a good piece of woodwork or jewelry, the fact of his being spiteful or debauched is immaterial, just as it is immaterial for a geometer to be a jealous or wicked man, if his demonstrations provide us with geometrical truth. As Thomas Aquinas put it, Art, in this respect, resembles the virtues of the Speculative Intellect: it causes man to act in a right way, not with regard to the use of man's own free will, and to the rightness of the human will, but with regard to the rightness of a particular operating power. The good that Art pursues is not the good of the human will, but the good of the very artifact. Thus, art does not require, as a necessary precondition, that the will or appetite should be straight and undeviating with respect to its own nature and its own—human or moral—ends and

dynamism, or in the line of human destiny. Oscar Wilde was but a good Thomist when he wrote: "The fact of a man being a poisoner is nothing against his prose." What does Thomas Aquinas state? "The kind of good, he says, which art pursues is not the good of the human will or appetite [or the good of man], but the good of the very works done or artifacts. And consequently art does not presuppose straightness of the appetite [in the line of the human good]."[1]

Here we are confronted with one of the basic principles which hold sway over the issue that we are tackling. This principle needs to be correctly understood and correctly applied. It needs to be counterbalanced by other basic principles, which pertain to the field of morality; over and above all it has to be complemented by the consideration of the fact that the artist is not Art itself, or an impersonation of Art come down from some Platonic separate heaven—but a man, the artist is a man using Art.

Yet the principle in question holds true and must never be forgotten. Art by itself tends to the good of the work, not to the good of man. The first responsibility of the artist is toward his work.

Let us observe at this point that in serving beauty and in serving poetry the artist serves an absolute, he loves an absolute, he is a captive of the absoluteness of a love which exacts his whole being, flesh and spirit. He cannot consent to any division. A bit of heaven which he obscurely shelters in his mind—namely creative or poetic intuition—is the pri-

[1] *Sum. theol.*, I-II, 57, 4.

mary rule to which his whole fidelity, obedience and heed-fulness must be committed.

Be it added, parenthetically, that creative intuition does not make superfluous the rules of working Reason. On the contrary it demands to use them as a necessary instrument. When the resourcefulness of discursive Reason, and the rules involved—the secondary rules—are used as instruments of creative intuition, they compose the indispensable arsenal of prudence, shrewdness and cleverness of the life of Art. It is at this flair and patient guile that Degas pointed, when he said: "A painting is a thing which requires as much cunning, rascality and viciousness as the perpetration of a crime."[1] Do we have here that part of the devil of which Gide spoke when he said: *The devil co-operates in any work of art?* No. What Gide intended was quite different; we shall have to discuss it later. At the moment we have only to do, in any case, with a quite innocent devil, the devil of shrewdness and trickiness in applying the rules.

3.

I have just insisted that Art taken in itself tends to the good of the work, not to the good of man, and that its transcendent end is Beauty, an absolute which admits of no division.

Now we shall deal with the other side of the medal, the opposite aspect of our problem. No longer with the realm

[1] Quoted from Etienne Charles in *Renaissance de l'Art français,* April, 1918. See my book *Art et Scolastique,* p. 81.

of Art, but with the realm of Morality. No longer with the order of Making, but with the order of Doing. No longer with the practical activity of the Reason as directed toward the good of the work to be made, but with the practical activity of the Reason as directed toward the good of human life to be reached, through the exercise of freedom.

What are the basic components of the realm of morality? The first notion which occurs is the notion of moral good.

The Good in general belongs to the order of transcendentals. Good is transcendental as Being is, and Good is coterminous with Being. Everything which exists is good to the extent to which it *is*, it possesses being. For the Good, or the Desirable, is fullness of being.

The notion I just stressed is the notion of metaphysical or ontological good—not the notion of moral good.

Moral good is that kind of good which is peculiar to man and to human life, and to the exercise of the human will. That kind of good through which man is caused to be good, purely and simply good.

The next question is, of course: what is the determining factor which makes a man purely and simply *good*?

A man can be rich, successful, powerful, etc., a good businessman, a good political boss, a good rancher, and be at the same time a bad man.

A man can be endowed with exceptional intelligence and possess every kind of knowledge, he can be a great scientist or a great philosopher, and be at the same time a bad man.

A man can be a great artist and be a bad man.

What causes a man to be purely and simply good is the goodness of his deeds as expressing his will; it is the action which achieves his being and emanates from him as a man, that is, as a person master of himself and capable of working out his own destiny, or as a free agent.

When we think of a man who endangers his own life to rescue perishing people, or of a man who endures persecution because he refuses to participate in injustice, or of a man who permits himself to be slandered and calumniated rather than betray a secret with which he has been entrusted, we feel a liking for this man, we envy him, we would like to act in the same way. Perhaps we are unable to do so—under the same circumstances we would have yielded. (Those who lead a bad life do not fail to admire virtue, and sometimes they are the most exacting as to the virtue of others). For all that, we admire this man, we think that he is a good man, a righteous man. At this point we have grasped the notion of the moral good.

And by the same token we are confronted with the emergence of an order different from the whole physical or metaphysical order; we are confronted with the emergence of a new order or a new universe, the order or universe of morality. If human actions were mere events of nature, resulting from the interaction of the constellations of causes at work in the world, there would be only the universe of nature—there would be no ethical universe, no universe of morality. But human actions are introduced into the world as the result of a free determination, as something which depends on an initiative irreducible to the causal connections

at play in the whole world, and taken by another whole which is my self, my own person, in such a way that I am responsible for it. I myself am the author of my action, be it good or bad.

Let us come to a further point: what is the determining quality which causes my action to be good? Good means fullness of being. Now anything attains the fullness of its own being when it is formed according to the form required by its nature. And because man is an animal endowed with reason, the form which is essentially required by his nature for his actions to possess fullness of being is the form of reason. A human action is good, purely and simply good, or morally good, when it is formed by reason, or measured according to reason. Conformity with reason, or consonance with reason, that is, conformity with what causes a man to be a man, is what causes a human action to be good.

Well, the fact of a human action being good or bad constitutes its intrinsic moral value. This notion of moral value has nothing to do with that of aesthetic or artistic value. Virtue is spiritually beautiful, and the Greeks had a single word, *kalokagathos, beautiful-and-good*, to designate the moral good. But this intrinsic beauty or nobility of the good moral action does not relate to a work to be made, it relates to the exercise of human freedom. Furthermore it is not good as a means to an end, it is good in itself—what the ancients called **bonum honestum**, good as right, the quality of an act good for the sake of good. Here we are not confronted with "a good state of affairs," meaning an advantageous or useful state of affairs, we are confronted with

that goodness, beauty or nobility which comes to a human act from its conformity with reason, and which is an end in itself, a good in itself.

Artistic value and moral value belong to two different realms. Artistic value relates to the work, moral value to man. The sins of men can be the subject-matter of a work of art, from them art can draw aesthetic beauty—otherwise there would be no novelists. The experience of moral evil can even contribute to feed the virtue of art—I mean by accident, not as a necessary requirement of art. The sensuality of Wagner is so sublimated by the operation of his music that *Tristan* calls forth no less than an image of the pure essence of love. The fact remains that if Wagner had not fallen in love with Matilda Wesendonck, we would probably not have had *Tristan*. The world would doubtless be none the worse for it—Bayreuth is not the Heavenly Jerusalem. Yet thus does art avail itself of anything, even of sin. It behaves like a god; it thinks only of its own glory. The painter may damn himself, painting does not care a straw, if the fire where he burns bakes a beautiful piece of pottery.

The fact matters to the painter, however, because the painter is not the art of painting, nor is he merely a painter. He is also a man, and he is a man before being a painter.

*

With the notion of value we are in a static order, in the order of what Aristotle called formal causality. When it comes to the dynamic order, to the order of exercise or

effectuation into existence, we are confronted with another component of the realm of morality—with the notion of end, and of ultimate end.

For by necessity of nature man cannot exercise his freedom, man cannot act except in the desire for happiness. But what man's happiness is, what human happiness consists of, this is not inscribed in the necessary functioning of his nature, this is above this necessary functioning. Because man is a free agent. Thus he has to decide for himself what kind of supreme good his happiness consists of in actual fact, he must choose his own happiness or supreme good, and the fate of his moral life depends on the fact of his choice being made or not according to the truth of the matter.

Let us suppose a man confronted with a choice deep and serious enough to engage his whole personality, and the whole direction he is giving to his life. Say this man decides to commit a murder because he needs money. He knows that murder is bad, but he prefers to the moral good that good which is money and which will permit him to satisfy his ambition. He is carried along by a love for a good (an ontological good) which is not the good for the sake of the good, but a good for the sake of his own covetousness. At this very moment he makes his life appendent to a supreme good or ultimate good which is his Ego.

Now let us think of Antigone who decides to brave an unjust law and to give her own life to bury her dead brother. She chooses to do this good for the sake of the good. She sacrifices her life to something which is better and dearer to her than her life and which she loves more.

At this very moment, because she prefers the good for the sake of the good, she directs her life, knowingly or unknowingly, toward a good which is supreme in a given order, namely the common good of the city (for the unjust law of the tyrant is destructive of this common good). Nay more, she makes, knowingly or unknowingly, her life appendent to an absolutely supreme good, an absolutely ultimate end which is the absolute good, the good subsisting by itself, the infinite transcendent good, that is, God. Any man who, in a primary act of freedom deep enough to engage his whole personality, chooses to do the good for the sake of the good, chooses God, knowingly or unknowingly, as his supreme good; he loves God more than himself, even if he has no conceptual knowledge of God.

If man existed in a purely natural order, or, as the theologians put it, in a state of pure nature, God, who is man's real supreme good and ultimate end, would not be, for all that, the absolute happiness or beatitude of man, for in the purely natural order there would be no absolute happiness or beatitude for man. His happiness, even beyond the grave, would be a happiness in motion, ceaselessly progressing, and never totally achieved.

Christianity—not philosophy—Christianity has taught us that man is called to a supernatural life, which the Gospel terms eternal life, and in which, through divine grace, he participates in the very life of God. Then God, who is man's real supreme good and ultimate end, will also be his absolute happiness or his beatitude, because man will

possess God by seeing Him intuitively. Well, from the point of view of pure nature, we would have every reason to doubt that man can ever reach absolute happiness. The fact that we really can be absolutely happy, and that we are cut out to be absolutely happy, is a datum of faith. The fact that every one of us, knowingly or blindly, craves for beatitude is an indication that we do not exist in a state of pure nature. This means that, in the order of exercise, which is the dynamic and existential order of final causality, the enforcement with respect to any choice engaging our whole personality and the whole direction of our life, of the moral good into actual existence, implies that we direct our life toward the subsisting Good as our supreme good. The entire moral order, the entire realm of morality is thus appendent to a love which is love for God as supreme ruler of human life, nay more, according to Christian data, which is love for God as loving us first and causing us to participate in His own life.

Such is not the case with the realm of art. Art and Poetry tend to an absolute which is Beauty to be attained in a work, but which is not God Himself, or Beauty subsisting by itself. When Cocteau said, at the end of *Orpheus:* "Because Poetry, my God, it's you," this did not mean that Poetry is God Himself, but that God is the prime Poet, and poetry receives all its virtue from Him. The absolute toward which Art and Poetry are directed is a supreme good and an ultimate end in a given order, in the order of the creativity of the spirit, it is not the absolutely ultimate end. What the

artist, insofar as he is an artist, loves over and above all is Beauty in which to engender a work, not God as supreme ruler of human life nor as diffusing his own charity in us. If the artist loves Him over and above all, he does so insofar as he is a man, not insofar as he is an artist.

4.

I have said that reason is the form, or measure—or the immediate rule—of human actions. Now God alone is measure measuring without being in any way measured. Human reason, in order to measure human actions, needs itself to be measured. By what measure is reason measured in this connection? By that ideal order, grounded on human nature and its essential ends, which Antigone called the unwritten laws, and which philosophers call the natural law. I shall not discuss natural law here; I should like only to insist that natural law is known to men, not through conceptual and rational knowledge (philosophers know and elucidate natural law in this way, but this is reflective knowledge, after-knowledge)—natural law is known to men through inclination or connaturality, a kind of knowledge in which the judgment of the intellect conforms to the inclinations existing in the subject. And this natural knowledge of natural law has developed in mankind, from the primitive ages on, slowly and progressively, among an infinity of accidents, and will always develop.

The point I should like to make is that human reason knows what is good and what is bad to the extent to which

it knows—naturally or instinctively, that is, through inclination—natural law, and is able to deduce the consequences implied in the principles of natural law. Now what about the feeling of moral obligation? This feeling depends on the inner constraint exercised on our will by our intellect, from the very fact that it knows the good and the bad, that is to say, moral values.

For we cannot want to be bad, we cannot want to do evil insofar as it is evil. Hence, when we know that something is bad—and therefore should be avoided—by the same stroke we feel bound not to do it. Moral obligation does not proceed from social taboos. Moral obligation is a constraint exercised by the intellect on the will. At this point a basic distinction must be made. When we consider things in an abstract and theoretical manner, we see human actions in their pure and universal moral essence, separately from what we are at a given moment, and from the tissue of concrete cirmumstances in which we are involved at this given moment. We see for instance that murder is bad. This murder which fits my anger is bad: if I do it I shall be bad, and I cannot want to be bad. This vision binds me. I am "bound in conscience." This is moral obligation, which takes place at the level of the abstract consideration of moral essences taken in themselves.

But there is another level, purely practical this time, the level of the actual choice, of the act of freedom. Then I can make a choice contrary to my conscience, and contrary to moral obligation. Because then I do not consider murder, for instance, in its pure and universal moral essence, but with

respect to what I am, and desire, and love, and prefer, here and now. I can say: this act is bad and forbidden by the law, but my good and that which I love most is to satisfy my anger; I make murder be what I love best—and so much the worse for the universal law! Then I choose murder not because it is bad, but because in respect to concrete circumstances and to the love which I freely make prevalent in me it is good for me. But not morally good! And in order to choose it, it is necessary that at the very instant of my act of choice, I divert my eyes from the vision of this action as morally bad, or, as Thomas Aquinas puts it, that I divert my eyes from the consideration of the rule. Thus it may be said, no doubt, that, as far as my act of choice is concerned, when I commit a deliberate moral fault I prefer to be bad (morally bad); but it is so because (having voluntarily diverted my attention from the moral law at the instant of free choice) I have made a good other than the moral good into my own *not-being-bad*. And the fact remains that I cannot want to be bad (morally bad) as far as the judgment of my conscience is concerned, or as far as my intellect considers the standards of man's conduct in their own right.

To sum up, my contention is that moral obligation, which does not deal with the existential choice, but with moral essences taken in themselves, depends on our vision of values, not on our movement toward the ultimate end. I shall miss my true end if I do evil. But I am not morally obliged to avoid evil because I shall miss my end if I do evil. In such a case I act against the moral obligation which

binds me. The fact remains that I am morally obliged. And I am morally obliged to avoid evil because, as far as the judgment of my conscience is concerned, if I do evil I shall be bad, and because I cannot want to be bad. By virtue of the very nature of my will, I feel bound in conscience, or in my apperception of the abstract and universal moral essence of human acts, *not to do* what would *make me bad*.

That which takes place with regard to the moral conscience of man as man is exactly what takes place with regard to the artistic conscience of the artist, as well as with the medical concience of the physician or with the scientific conscience of the scientist. The artist cannot want to be bad as an artist, his artistic conscience binds him not to sin against his art, for the simple fact that this would be bad in the sphere of artistic values. Tell a Rouault or a Cézanne to change his style and do more *pleasing* painting, bad painting, in order to be accepted at the annual Exhibition of French Artists and make a living and support his family, and fulfill his moral obligations towards his wife and his children; even assuming that his family is starving, he will answer: get out and leave me alone, you fool! To follow such advice would be against his artistic conscience, his conscience as a painter. To support his family an artist may have to become a farmer, or a customs officer, as did Hawthorne or Henri Rousseau, or even to give up art. He can never accept to be a bad artist, and spoil his work.

I knew a great writer who also had an extraordinary gift for drawing. When he was a young man he made drawings which had some kinship with those of William Blake. But

he felt that in doing so he obeyed a sort of dark inspiration, with so to speak a forbidden ease; he thought he was guided by the devil. He gave up drawing completely. It was possible for him to do this. It would not have been possible for him to spoil his drawings by betraying his vision.

At this point a serious issue arises, which we shall discuss later on; and a remark which seems quite important to me can be made right now: for an artist to spoil his work and sin against his art is forbidden by his artistic conscience. But what about his moral conscience? Is not his moral conscience also involved? My answer is yes. Not only his artistic conscience, but his moral conscience also, his conscience as a man is here on the alert. For moral conscience deals with all the acts of a man; moral conscience envelops, so to speak, all the more particularized kinds of conscience—not moral in themselves, but artistic, medical, scientific, etc.—of which I just spoke. There are no precepts in natural law or in the Decalogue dealing with painting and poetry, precribing a particular style and forbidding another. But there is a primary principle in moral matters, which states that it is always bad, and always forbidden, to act against one's own conscience. The artist who, yielding to ill-advised moral exhortations, decides to betray his own singular truth as an artist, and his artistic conscience, breaks within himself one of the springs, the sacred springs, of human conscience, and to that extent wounds moral conscience itself.[1]

*

[1] See *infra*, pp. 62-64.

We have spoken of values, which refer to the order of formal causality and of specification—of the ends and the ultimate End, which refer to the order of final causality and of exercise—of moral law and moral obligation. Now by what means does man become able to enforce in actual existence moral standards and moral regulations, or to make his actions consonant with Reason?

Here we are confronted with the notion of moral virtue. Virtues, as perennial philosophy sees them, are stable dispositions or inner forces developed in the soul, which perfect its operative powers in a certain line or direction. Moral virtues—say, the four cardinal virtues, Prudence, Justice, Fortitude, Temperance, recognized by the Graeco-Roman philosophical tradition—perfect and fortify the intellect, the will and the appetitive powers in the line of morality. They are connected with one another, but the principal of them, the queen of moral virtues, is Prudence, that is, practical Insight and Wisdom, because it has to do with the Intellect and the command of our actions.

The main point to be made with regard to Prudence is that Prudence is (like Art, though in the sphere of Doing, not of Making) a virtue of the Intellect, of the Practical Intellect, but is in no way a science, even a practical science. Prudence is not a set of ready-made general truths and general rules—particularized as they may be—for applying moral rules. There is no fixed and ready-made rule to apply the rules. The only definitive measure is the very rectitude of the appetite. The act of moral choice is so individualized (both by the singularity of the person from whom it

emanates and by that of the context of contingent circum-
stances in which it takes place) that the practical judgment
in which it is expressed and by which I declare to myself
"This is what I need," can only be right if actually, *hic et
nunc*, the dynamism of my willing is right and tends toward
the genuine good of human life.

So much for the ruling and dominating part, the royal
part played by the virtue of Prudence, both intellectual
and moral, in human life.

But we know that Art is another virtue—intellectual, not
moral—of the Practical Intellect, and that it is concerned
with the good of the work, not with the good of man.

At this point appears the relationship—and the conflict—
between Art and Prudence. The artist as an artist has ends
which deal with his work and the good of his work, not with
human life. The artist as a man has ends which deal with his
own life, and the good of his own life, not with his work.
If he took the end of his art, or the good of his artifact, for
his own supreme good and ultimate end, he would be but an
idolater. Art in its own domain is sovereign like wisdom;
through its object it is subordinate neither to wisdom nor
to prudence nor to any other virtue. But by the subject
in which it exists, by man and in man it is subordinate—
extrinsically subordinate—to the good of the human subject.
As used by man's free will art enters a sphere which is not
its own, but the sphere of moral standards and values, and in
which there is no good against the good of human life.
Whereas Art is supreme with respect to the work, Prudence

—that is, moral wisdom, the virtue of right practical decision—Prudence is supreme with respect to man.

What makes the conflict bitter is the fact that Art is not subordinate to Prudence by virtue of their respective objects, as science, for instance, is subordinate to wisdom. As concerns its own objects, everything comes under the purview of Art, and of Art alone. But as concerns the human subject, nothing comes under Art's purview. Over anything made by the hand of man Art and Prudence each claim dominion. From the point of view of poetic, or, if you will, working values, Prudence is not competent. From the point of view of human values, and of the moral regulation of the free act, Prudence alone is competent, and there is no limitation upon its rights to govern.

When he reproves a work of art, the Prudent Man, standing squarely upon his moral virtue, has the certitude that he is defending against the Artist a sacred good, the good of man, and he looks upon the Artist as a child or a madman. Perched on his intellectual virtue, the Artist has the certitude that he is defending a no less sacred good, the good of Beauty, and he looks as though he were bearing down on the Prudent Man with the weight of Aristotle's maxim: "Life proportioned to the intellect is better than life proportioned to man."

From the point of view of Art, the artist is responsible only to his work. From the point of view of Morality, to assume that "it does not matter what one writes" is permissible only to the insane; the artist is responsible to the good of human life, in himself and in his fellowmen.

Thus, what we are confronted with is the inevitable tension, sometimes the inevitable conflict, between two autonomous worlds, each sovereign in its own sphere. Morality has nothing to say when it comes to the good of the work, or to Beauty. Art has nothing to say when it comes to the good of human life. Yet human life is in need of that very Beauty and intellectual creativity, where art has the last word; and art exercises itself in the midst of that very human life, those human needs and human ends, where morality has the last word. In other words it is true that Art and Morality are two autonomous worlds, each sovereign in its own sphere, but they cannot ignore or disregard one another, for man belongs in these two worlds, both as intellectual maker and as moral agent, doer of actions which engage his own destiny. And because an artist is a man before being an artist, the autonomous world of morality is simply superior to (and more inclusive than) the autonomous world of art. There is no law against the law on which the destiny of man depends. In other words Art is indirectly and extrinsically subordinate to morality.

*

A last question must be tackled, which matters essentially to the realm of morality—namely the question: what does the perfection of human life consist of? Our preceding considerations make us expect the answer that Thomas Aquinas offers. Anything, he says, is called perfect insofar as it reaches its proper end, for in the attainment of the end con-

sists the ultimate perfection of a thing. Now it is through charity that we are united with God, who is the ultimate end of man, because, as St. John puts it, "God is love, and he that abideth in love abideth in God, and God abideth in him." Therefore it is in charity, when there is no longer any obstacle to its expansion in the soul, that the perfection of man consists.[1]

Thus St. Thomas teaches that perfection consists in charity, and that each of us is bound to tend toward the perfection of love according to his condition and insofar as it is in his power. All morality thus hangs upon love. The love of the One Who is better than all goodness, and of the creatures He has made in His image, is that in which man attains the perfection of his being. That perfection does not consist in supreme accuracy in copying an ideal. It consists in loving, in going through all that is unpredictable, dangerous, dark, demanding, and insensate in love; it consists in the plenitude and refinement of dialogue and union of person with person to the point of transfiguration which, as St. John of the Cross says, makes of man a god by participation, "two natures in a single spirit and love."

If the perfection of human life consisted in some stoic athleticism of moral virtue, and in a man-made righteousness achieved to the point of impeccability, all of us, and especially the Artist and the Poet, would be in a rather sad predicament in this regard, and we would have to despair of the possibility of a single wise man, as the late Stoics did. But if the perfection of human life consists in a ceaselessly in-

[1] Cf. *Sum. theol.*, II-II, 184, 1 and 2.

creasing love, despite our mistakes and weaknesses, between the Uncreated Self and the created self, there is some hope and some mercy for all of us, and especially for the Artist and the Poet.

The fact remains that the Prudent Man and the Artist have difficulty in understanding one another. But the Contemplative and the Artist, the one bound to wisdom, the other to beauty, are naturally close. They also have the same brand of enemies. The Contemplative, who looks at the highest cause on which every being and activity depend, knows the place and the value of art, and understands the Artist. The Artist in his turn divines the grandeur of the Contemplative, and feels congenial with him. When his path crosses the Contemplative's, he will recognize love and beauty.

I am sorry that I was obliged to refer to matters which go beyond philosophy, and pertain to the theological sphere. But I could not do otherwise, because the realm of morality deals with man as he is not only in his abstract essence, but also in his concrete and existential condition; and, because, as I have previously noticed, the existential condition of man is not purely natural. In relation to this existential condition there are certain data the knowledge of which depends on theology, not on philosophy. One of these data has to do with the virtues which come into play in the conduct of human life, and with that love of Charity of which I previously spoke. As a matter of fact there are other virtues besides moral virtues to be taken into consideration; these

other virtues, which are Faith, Hope and Charity, are God-given virtues, and are called theological virtues, for God Himself is their object. And the greatest, as St. Paul said, is Charity.

Thus it is that, fortunately for man, and fortunately for the artist, Prudence is indeed the queen of moral virtues, but this queen has been made into a servant with respect to Charity. The only real queen of all virtues is Charity, or that God-given love for God and our fellow-men which is God's love itself communicated to us. In the order of nature, there is no friendship possible, as Aristotle observed, between Jupiter and man, because friendship presupposes a kind of equality. But in the order of grace, precisely because grace raises man to share in the very life of God, there is between man and God real friendship, with that relationship from person to person and that community of goods which friendship implies. This love of friendship uniting God and man is grace-given Charity.

Charity does not cancel the need for Prudence and moral virtues. It requires them—in one sense it carries them along with itself in the soul—and it perfects them. But Charity transfigures moral life and changes the picture entirely, because it makes man intrinsically good and it makes him love the law, since he has become the friend of the author of the law. Thus moral law, which condemns us and is our enemy, as long as we are wicked, becomes itself our friend and our road to freedom. And in the end, when Charity has transformed man, Charity makes man accomplish the law without being enslaved to the law, because he does freely,

by love, what the law prescribes. Though Charity does not abolish the conflict between Prudence and Art, yet it enables man, if it takes hold of him, to solve this conflict in freedom, and to have Art, quickened by love, accord with Prudence, not as an enemy queen, but as a friendly servant of Charity.

Chapter II

Art for Art's Sake

Chapter II

Art for Art's Sake

I.

I HAVE tried to make clear the state of tension, or even of conflict, which naturally exists between Art and Morality, and which proceeds from the basic fact that Art is intent on the good of the work, not on the good of man, whereas Morality is intent on the good of man, not on the good of the work.

Of this opposition between the good or perfection of the work and the good of man or the perfection of his life the artists are clearly aware. They even overemphasize the opposition, as Yeats did in *The Choice*:

> The intellect of man is forced to choose
> Perfection of the life, or of the work,
> And if it take the second must refuse
> A heavenly mansion, raging in the dark.
> When all that story's finished, what's the news?
> In luck or out the toil has left its mark:
> That old perplexity an empty purse,
> Or the day's vanity, the night's remorse.

Now it is of a vicious conception, a misuse and misinterpretation of the truths I emphasized concerning Art, or the

47

fact that Art, of itself, tends only to the good of the work, that I should like to speak. In other words, I shall discuss the motto *Art for Art's sake*, a motto which in the last analysis originates in a *hypostasierung*, a substantification or hypostatization of Art, or a confusion between Art taken in itself and separately, which exists only in our mind, and Art as it really exists, that is, as a virtue of man—in other words a confusion between the artist abstractly cut off from man, and man the artist.

The motto *Art for Art's sake* simply disregards the world of morality, and the values and rights of human life. *Art for Art's sake* does not mean Art for the work, which is the right formula. It means an absurdity, that is, a supposed necessity for the artist to be only an artist, not a man, and for art to cut itself off from its own supplies, and from all the food, fuel and energy it receives from human life.

To tell the truth, art took to enclosing itself in its famous ivory tower, in the XIXth century, only because of the disheartening degradation of its environment—positivist, sociologist or materialist attitudes. But the normal condition of art is altogether different. Aeschylus, Dante, Cervantes, Shakespeare or Dostoievsky did not write in a vacuum bell. They had large human purposes. They did not write assuming that it did not matter what they wrote. Did not Dante believe he was giving only a higher course in catechism and turning his readers toward the business of their eternal salvation? Did not Lucretius intend to spread the Epicurean system, Virgil, when he composed the *Georgics,* to bring man-power back to the land and Wagner to glorify the

Teutonic religion? For all that, they did not go in for propaganda art—even Wagner, though with Wagner I am not so sure. But the fact that Frenchmen of my generation consider Wagner a great corrupter of music, an abortive magician is beside the point. What I mean is that with all the genuine artists and poets, the richer the human stuff, the more strongly was everything mastered for the good of the work and subordinated to the inner self-sufficiency of this self-subsisting cosmos.

*

For, as I have said, Art is not an abstract entity without flesh and bones, a separate Platonic Idea supposedly come down on earth and acting among us as the Angel of Making or a metaphysical Dragon let loose; Art is a virtue of the practical intellect, and the intellect itself does not stand alone, but is a power of Man. When the intellect thinks, it is not the intellect which thinks: it is man, a particular man, who thinks through his intellect. When Art operates, it is man, a particular man, who operates through his Art.

In the very line of the artistic production or creation, that which exists and requires our consideration, that which is the agent, is man the artist.

It is nonsense to believe that the genuineness or the purity of a work of art depends upon a rupture with, a moving away from the living forces which animate and move the human being—it is nonsense to believe that this purity of the work depends on a wall of separation built up between art

and desire or love. The purity of the work depends upon the strength of the inner dynamism which generates the work, that is, the strength of the virtue of art.

No wall of separation isolates the virtue of art from the inner universe of man's desire and love.

There exists, to be sure, a special desire and love which is simply one with the activity of the artist, consubstantial with this activity. That is the desire and love to create a work. Discussing Henri Bremond's book on pure poetry T. S. Eliot said: "My first qualm is over the assertion that 'the more of a poet any particular poet is, the more he is tormented by the need of communicating his experience.' This is a downright sort of statement which is very easy to accept without examination; but the matter is not so simple as all that. I should say that *the poet is tormented primarily by the need to write a poem*."[1] Yet Eliot's accurate remark must not mislead us: in the very urge toward the work and toward creation the desire is involved, not precisely to communicate our experience to another, but to express it: for what is creation if not an expression of the creator? Man's substance is unknown to himself. It is when he grasps things through emotion that for the poet things and the self are awakened together, in a particular kind of knowledge, obscure, ineffable in itself, which can be expressed only in a work, and which is poetic knowledge. At this point we are confronted with the essential part played by subjectivity, by the self, in poetic knowledge and poetic activity.

An oriental critic, Mr. Lionel de Fonseka, in his book *On*

[1] T. S. Eliot, *The Use of Poetry*, p. 138.

*the Truth of Decorative Art, A Dialogue between an Ori-
ental and an Occidental,* has written that vulgarity always
says *I*. Well, vulgarity says *one* also, and this is the same
thing, for vulgarity's *I* is nothing but a neuter subject of
predicates or of phenomena, a subject as matter, marked with
the opacity and voracity of matter, like the *I* of the egoist.

But in an entirely different manner poetry likewise al-
ways says *I*. Listen to the Psalms: "*My* heart hath uttered a
good word," "Vivify *me* and *I* will keep thy command-
ment . . ." Poetry's *I* is the substantial depth of the living and
loving subjectivity, it is a subject as act, marked with the
diaphaneity and expansiveness proper to the operations of
the spirit. Poetry's *I* resembles in this regard the *I* of the
Saint, and likewise, although in other fashions, it is a subject
which gives. The art of China and of India, like that of the
Middle Ages, may well shelter itself behind the rite or the
simple duty of ornamenting life; it is as personal as that of
the individualistic Occident. The more or less rigorous
canonicity of art is here a secondary condition; in the days
of old it was a condition favorable for hiding art from itself.
But the consciousness of itself, and at the same time its
newly acquired taste for freedom are fine dangers which
mobilized poetry.

Well, my contention is that, by necessity, as a corollary of
the preceding observations on the nature of poetic knowl-
edge, which is at the core of poetic activity, poetic activity
is, of itself, essentially disinterested. It engages the human
self in its deepest recesses—but in no way for the sake of
the human Ego. The very engagement of the artist's Self in

poetic activity, the very revelation of the artist's Self in his work, together with the revelation of the particular secret he has obscurely grasped in things, are for the sake of the work. The self is both revealing itself and sacrificing itself, because it is given, it is drawn out of itself in that sort of ec-stasy which is creation, it dies to itself in order to live in the work, and how humbly and defenselessly!

What does this essential disinterestedness of the poetic activity mean? It means that egoism is the natural enemy of poetic activity.

The artist as a man can be busy only with his desire and love for creation. He can say like Baudelaire "I don't give a damn for the human race," he can be concerned only with his work, like Proust, he can be an out-and-out egoist, as Goethe was: in his process of creation, insofar as he is an artist, he is not an egoist, he is freed from the greed of the Ego.

And obviously the artist can also have his desire and love for creation involved in the movement of expansion and generosity of a soul whose passions and ambitions are not of an egoist. And such internal abundance and magnanimity are even the normal and connatural climate of the virtue of the poet; narrowness and avarice in human desires make it live in cold and hail. After all, Shelley was right in writing that the "state of mind" naturally linked with poetic inspiration *"is at war with every base desire"*;[1] though he went

[1] *The Great Critics*, edited by James Harry Smith and Edd Winfield Parks, New York: W. W. Norton, 1939, p. 579.

perhaps a little too far when he added: "A poet, as he is the author to others of the highest wisdom, pleasure, virtue and glory, so he ought personally to be the happiest, the best, the wisest and the most illustrious of men."[1] The artists of the Renaissance were not, as men, models of wisdom, disinterestedness and benevolence. But at least they were interested in great causes and ideals, they had great human aspirations, and even their pride and their vices throve on a generous blood.

Let us observe in addition that many elements in the work itself can convey the resentment or the maliciousness of its author. A rhythm, a musical motif, a brush stroke, a color can be malicious. But the melody in a work, sonata, picture or poem cannot be malicious. The melody, as Arthur Lourié put it, is always good, *la mélodie est toujours bonne,* because the melody is the most immediate vehicle of the poetic sense. And he went on to say: "It is perhaps because we have become wicked that we have lost or claim to have lost melody."[2]

It is, I think, by reason of the essential disinterestedness, which I just pointed out, of the poet in the very act of poetry, and by reason of his natural orientation toward creation, that the poets and artists of the past have given us such poor indications of their own inner creative experience. They spoke in the most conventional and shallow rhetoric and in the most commonplace stock phrases—*nascentur poetae,* the Muses, the genius, the poetic faculty, the divine

[1] *Ibid.,* p. 581.
[2] Arthur Lourié, "De la Mélodie," *La Vie Intellectuelle,* December 25, 1936.

spark, later on the Goddess of Imagination—of this experi-
ence which at least the greatest among them lived in fact, no
doubt, but which their conscious intellect did not seek to
grasp. They were not interested in reflective self-awareness.
The age of reflection, the age of *prise de conscience*, which
roughly speaking started for Mysticism at the time of St.
Theresa of Avila and St. John of the Cross, came later for
Poetry. When it did come for Poetry, at the time of
Romanticism, it brought to completion the slow process of
revelation of the Self which had progressively developed in
the course of modern centuries. This revelation of the crea-
tive Self is a blessing to the extent to which it takes place in
the genuine line of Poetry. But it becomes a curse when it
shifts from the line of Poetry, and of the Self in the fire of
spiritual communication, to the line of man's material in-
dividuality, and of the Self as jealous proprietor and center
of insatiable lusts. Then the egoism of man enters the very
sphere of the poetic act, not only to spoil it, but to feed on it.
On the one hand such growth of the human egoism, being
unnatural, becomes boundless; on the other hand, as regards
the creative act, the artist no longer manifests himself and
the world in his work—he unloads himself in it, pours his
own complexes and poisons into it, and into the reader, thus
achieving a psychological cure at the expense of both.

The accident came about, sad to say, simultaneously with
the most glorious discoveries achieved by the self-awareness
of Poetry as Poetry. And nevertheless—this is the point I
should like to make—the essential disinterestedness of the
poetic act is so ineradicable that the final result of this in-

vasion of the human Ego in the universe of art was not, in actual fact, to make the artist into a creative usurer (that is a contradiction in terms) but to make him (a fact to which I shall return at the end of this chapter) into a hero, a priest, or a savior, offering himself in sacrifice no longer to his work but both to mankind and to his own glory.

2.

Let us come back now to the discussion of *Art for Art's sake*. The previous considerations help us to realize that, from the point of view of ends, or of final causality, it is only normal that the desires and loves with which human life is filled should be at play in the soul of the artist. They tend toward ends which are not the proper ends of art. But they feed and nourish art and poetry, and they will not warp the work, they will enrich it, if only art and poetry themselves tend purely and unyieldingly to their own ends in the making of the work. No doubt, I know that when it comes to a particular human purpose for which the work is done—propaganda plays, patriotic poems and moralizing literature do not add up to much as a rule. But this is so because, as a rule, the artist has allowed his moral idea to enter the very sphere of the making and to act as a way of making, which it is not. I also know that the cathedral builders had no sort of thesis in mind, nor did they want to suggest a Christian emotion. But they had Faith, and it was enough. The human ends with which I am concerned here are not particular purposes, but rather the things in which the artist

believes, and which he loves. In this sense it is only normal that a poet or a writer, a man who works with words should have a message, not only his proper artistic message (which is the essential) but also a human message of his own, silly, foolish or momentous, to deliver to men. Otherwise there would be a serious possibility that his work would have nothing to say. Such was, I dare say, the fate of Mallarmé's narcissism. Earlier I mentioned Dante, Virgil and Lucretius; to these I might add Tolstoy, Walt Whitman, William Blake, Léon Bloy, Nietzsche. There is nothing to stop Gide from saying: it does not matter what one writes. But in reality he himself was constantly prodded by a kind of apostolic zeal—rather particular in nature, to be sure, but that's another question—the chief intent of which was to justify himself in the eyes of men.

The workman works for his wages, and the most disincarnate artist has a concern, concealed or repressed as it may be, to act upon human souls and to serve an idea. What is required is the perfect practical discrimination between the aim of the workman (*finis operantis,* as the Schoolmen put it) and the aim of the work *(finis operis):* so that the workman should work for his wages, but the work should be ruled and shaped and brought into being only with regard to its own good and in nowise with regard to the wages. Thus the artist may work for any and every human intention he likes, but the work taken in itself must be made and constructed only with regard to the creative intuition in which it originates and to the rules of making which it calls for.

*

Similar considerations may be put forward from the point of view of the agent who operates or of efficient causality. Plato said that a philosopher must philosophize with his whole soul (though the intellect alone is the proper organ of philosophy). The same may be said of the artist.

The virtue of art does not allow the work to be interfered with or immediately ruled by anything other than itself. It insists that it alone shall touch the work in order to bring it into being. In short, art requires that nothing shall attain the work except through art itself. It is through His word and His art that God attains, rules and brings into being everything He makes. In the same way it is through art that the human artist must attain, rule and bring into being all his work.

But this in no way implies that the work depends on art alone, and not on the entire soul of the artist; that it is made by the art alone, separate, cut off from all the rest in man, and not by man the artist with all the human purposes, desires, and longings, all the human thoughts and beliefs he has in his heart. Theologians tell us that everything was made *per Verbum*, through the Divine Word, yet it is also true that everything was made by the whole undivided Trinity: in a manner totally free from the least interested intention, but to an end nevertheless, an end which is not simply the perfection of the work to be achieved, and which is of an order superior to art—the communication of divine goodness.

*

Finally, our issue has also to do with the perspective of material causality.

It would simplify many questions to make a distinction between art itself and its material or subjective conditions. Art being of man, how could it not depend on the pre-existing structures and inclinations of the subject in which it dwells? They remain extrinsic to art, but they influence it.

Art as such, for instance, transcends, like the spirit, every frontier of space or time, every historical or national boundary. Like science and philosophy, it is universal of itself.

But art does not reside in an angelic mind: it resides in a soul which animates a living body, and which, by the natural necessity in which it finds itself of learning, and progressing little by little and with the assistance of others, makes the rational animal a naturally social animal. Art is therefore basically dependent upon everything which the human community, spiritual tradition and history transmit to the body and mind of man. By its human subject and its human roots, art belongs to a time and a country.

3.

The last part of this chapter will deal with the artist in relation to the community, in other words, with the problem of the moral responsibiilty of the artist with regard to men. All that we have seen shows that this responsibility exists. Since morality is not a branch of aesthetics, the problem cannot be avoided.

Every work of art reaches man in his inner powers. It reaches him more profoundly and insidiously than any rational proposition, either cogent demonstration or sophistry.

For it strikes him with two terrible weapons, Intuition and Beauty, and at the single root in him of all his energies, Intellect and Will, Imagination, Emotion, Passions, Instincts and obscure Tendencies. The question is, as Léon Bloy put it, not to hit below the heart. Art and Poetry awaken the dreams of man, and his longings, and reveal to him some of the abysses he has in himself. The artist is not ignorant of that. How will he deal with this problem?

It is true, as I said at the beginning, that Beauty is an absolute which admits of no division, and that the artist is bound to serve this absolute. He is first responsible to his work. Now must he bend or force down his work and his art, in order that men should not chance to be led astray by them?

If the artist asks himself this question, not through fear of the public but by virtue of a genuine sense of his responsibility, it is because he loves the truth and thinks of his fellowmen with generosity. It is finally because he loves them. This means that he already has the answer. At this point I should like to appropriate, with a view to an issue which Rimbaud did not have in mind, the famous saying of Rimbaud: *la charité est cette clef*, Charity is the key. For it is inside the soul of the poet, in those very depths of the creativity of the spirit, where all the substance of man and all his yearnings and all his energies, emotional and intellectual, poetic and moral, are concentrated, that the conflict demands to be solved.

In the first place—but this is not the primary consideration—love makes those whom we love present within ourselves,

as a part, so to speak, of our own subjectivity. What is a beautiful work, on the other hand, if not a work that we love? When we cannot love a poem or a painting, it ceases to be beautiful for us, even if it is perfectly made. Suppose that you read a magnificent poem in which your mother is insulted and vilified—this poem cannot be beautiful for you: what remains of it, for you, is only a well-contrived artifact, but incapable of delighting the sight. Thus it is that literary criticism cannot, even from the sole point of view of beauty, rule out any consideration of the moral or ideological content of works.

Similarly, if the artist loves truth and loves his fellowmen, anything in the work which might distort the truth or deteriorate the human soul will displease him, and lose for him that delight which beauty affords. Respect for truth and for the human soul will become an objective condition or requirement affecting his virtue of art itself, just as a rule of prosody was for the classical poet, or as the necessity of having doors and windows in a house is for architecture, or as the necessity of making an image before which it is possible to pray is for sacred art. Such kinds of obstacles, if they are obstacles, have never obliged an artist to bend or force down his art. They oblige him to make his art more straight, and more powerful.

Yet this aspect of the question remains secondary, and accidental as it were. What matters most, and is essential, is the fact that love—I don't mean any kind of love, I mean love of Charity—when it takes hold of man, makes the entire subjectivity purer, and, consequently, the creative source also

purer. As François Mauriac put it, *to purify the source* is the only way. The reason for this is clear enough. While expressing and manifesting some inside aspect or secret of things in his work, what the artist expresses and manifests first and foremost in it is his own self, his own subjectivity—through the instrumentality of his virtue of art. As a result, any kind of distorted inclination or secret connivance with evil in himself will inevitably reflect on his work, one way or another, and the work—whatever things (perhaps horrible and shameful) it may describe—can be free of any inclination to, or connivance with, moral evil only if the source is a purified self.

A purified source is not, as Julian Green and Graham Greene would sometimes seem to think, a source which is timid or prudent, or with an admixture of chemicals. A purified source springs from the depths of man's substance, and is as wild and irrepressible as any other; but it has no mud. This is the work of self-discipline and the cultivation of moral virtues, but first of all of transforming love.

Then the artist need no longer think of the souls of his fellow-men. He can forget them, forget men and everything. He can do as he pleases, he is sure that his work will lead nobody astray.

The sentence of Mauriac which I just quoted is taken from a book, *Dieu et Mammon*, in which he struggles with Gide and insists that a *Christian novelist* is not a contradiction in terms. Gide insisted that the devil cooperates in any work of art. I am ready to grant that this is true, to some extent, as long as the source is not purified: for art taken in itself,

as we have seen, makes fun of everything save the glory of the work, and the devil makes mud in the source a fine ingredient for this glory. But when there is no mud, the devil loses his bite. And the art of a purified soul uses anything, even mud, for the glory of the work, with pure hands and with no connivance.

Here again the sole problem which always remains for the artist is not to be weak in his own God-given commission; to be in possession of an art strong and straight enough to be always master of everything it brings into play, without losing anything of its creative purity; and to be intent, in his very operation, on the good of the work alone, without being deflected or disturbed by the weight of the human or divine riches which fill his heart.

*

A further point must be made. As I said in the preceding chapter, the artistic conscience of the poet forbids him to change anything in the work which is required by the good of the work, as he sees it, and by his inner singular truth as a poet. And the moral conscience of the poet is also involved in this very fact, for it is always bad to act against one's own conscience. Now what happens, on the other hand, and from the point of view now of the human good, if the moral conscience of the artist, assuming he has any, declares that something in the work, as artistically good and necessary as he may see it, is morally bad and that therefore it must be changed?

What is the solution? Posed in these terms, the problem has no solution. As long as his artistic conscience commands him to do his work in this way, the conscience of the artist is divided against itself. He is in a state of insoluble perplexity. If he does not change his work, he will offend the moral law, and be wrong. If he changes his work, he will betray his conscience in another way, and also be wrong.

As a matter of fact, it is possible that the moral evil ascribed to a work is only apparent. Then there is no problem. It is also possible, and probable, that the moral conscience of an artist whose work is really pernicious is contaminated by questionable human inclinations, warped instincts, or resentments or vices, which he shelters behind his art: then he will claim, and perhaps sincerely believe, that his work is innocent and incapable of offending morality, and is even the greatest tribute ever paid to virtue. But this is not a solution, it is a fake, or an escape.

There is a solution, indeed, but more difficult than one would wish. The only solution for such an artist is to change, *not* his work (as long as he remains what he is), but *himself.* Then his artistic conscience itself will require of him another kind of work.

The Prudent man, if he has to intervene, does not trouble himself with these spiritual entanglements. He will brandish the moral law against this artist, and summon him to change his work, whatever his inner state of mind and his artistic conscience may be.

The Wise man, I think, will not do so. He knows that the social community has its legislators, its magistrates, its legions

of decency, its women's clubs, its Postmaster General, to defend itself against pernicious (or even supposedly pernicious) works of art. With regard to the artist himself in question, he will try to induce him to purify the source. There is no other real solution.

*

Let me point finally to a phenomenon which took place in the last century, and which might be called the imperialist invasion of art in the very domain of morality, that is, in human life. I spoke some moments ago of the distinction to be made between the creative self and the self-centered Ego, and of the manner in which self-awareness risks making the artist shift from one to the other.

Rousseau and the Romantics were the forerunners of the event. But the school of Art for Art's sake gave it its full dimensions. Through the effect of a strange dialectic, by virtue of the principle that the artistic value *alone* matters, this value, along with poetic creativity and the poetic act, instead of remaining enclosed in the ivory tower of Art for Art's sake, was to claim sovereignty over all of human life, and to perform a function which encompasses the destiny of mankind. In the Romantic period, Byron, Goethe, Hugo, had made themselves heroes "greater," as Mr. Blackmur puts it, "than any of the heroes in their works." "Arnold was making his claims that poetry might save the world by taking on the jobs of all the other functions of the mind at the expressive level." Then came the *poète maudit*, then the *supreme seer*

whom Rimbaud glorified. And then the artist found that he had "upon his hands the task of the deliberate creation of conscience in a conscienceless society."[1]

Thus, as the French critic Jacques Rivière put it, "the writer has become a priest . . . All XIXth century literature is a vast incantation toward the miracle."[2]

The ivory tower has become the cathedral of the world, the temple of the Pythoness, the rock of Prometheus and the altar of supreme sacrifice.

I submit that this very fact constitutes a refutation *per absurdum* of the theory of Art for Art's sake.

[1] R. P. Blackmur, "The Artist as Hero," *Art News*, September, 1951, p. 20.

[2] Jacques Rivière, "La Crise du Concept de Littérature," *Nouvelle Revue Française*, February 1, 1924.

Chapter III

Art for the People

Chapter III

Art for the People

I.

IN THE second part of the preceding chapter we considered the problem of the responsibility of the artist to men from the point of view of the artist and of his own conscience.

I should like to add, in relation to the saying of François Mauriac: *to purify the source*, on which I laid stress, that this maxim refers especially to writers. No doubt it matters in one sense to all artists, painters or composers as well as poets, inasmuch as they should, as men, and as every man, be concerned with their own spiritual good and their own progress toward the perfection of human life. And when the source becomes purer in them, by the same stroke their work itself will convey higher and larger *human* values: will this work also have greater *artistic* value, will it be artistically better or worse? That is a problem, a melancholy problem, which I shall try to tackle in my last chapter.

But Mauriac's saying is directed especially to writers and poets, and more especially to novelists. It is especially when it comes to writers that the maxim: purify the source, imposes itself in relation to the impact of the work on the

moral life and standards of other men, and on the moral
health of the community, and in relation to the possibly
vivifying and salutary, or possibly degrading and corrupting
influence of the work.[1] For the writer works with words,
which convey ideas and stir the imagination and which act
through intelligence on all the rational and emotional fabric
of notions and beliefs, images, passions and instincts on
which the moral life of man depends.

In my present discussion, therefore, I shall have especially
in view the case of the writer. But I shall not consider the
problem from the point of view of the artist and his own
conscience, as I did in my first chapter. I shall consider it
from the point of view of the other fellow, the point of
view of the public, the point of view of the human com-
munity.

Here we are confronted no longer with the motto *Art
for Art's sake*, but with an opposite motto, which appeals
today to many sociologically-minded or politically-minded
or humanitarian persons, and which is the motto: *Art for
the people*, or *Art for the community*.

I am aware of the fact that such a formula may relate
only to the intentions of an artist who is inspired by gener-
ous human purposes while his virtue of art is genuinely at
play for the good of the work, especially to the intentions
of an artist who is eager to have the joys of Beauty made
available not only to a privileged class but to the under-
privileged as well. Such a desire corresponds, I think, to a

[1] This saying should also apply to the moving picture industry, so
far as industry has a conscience.

basic need and necessity. But let me observe parenthetically that it is best fulfilled when an artist is more concerned with future generations and the spiritual community of mankind as a whole than with the common people of his time, and when, on the other hand, the great works of art, once created, are made available to all through the channel of libraries, museums and other modern media of communication, and by making all members of the community capable of enjoying them thanks to a liberal education for all:—these things are the job of the community, not of the artist himself. As a matter of fact, the attempts to put creative activity itself at the service of the common people have generally been a failure.

Well, if the motto *Art for the people* is understood in the manner I have just suggested, I have nothing against it. But as it is used in actual fact, this motto relates to the exigencies of those who, speaking in the name of the human community, want to raise the needs or ideals of the community to the status of a rule of creation imposed on the very making of the work. In this sense, just as Art for Art's sake simply disregards the world of morality, and the values of human life, and the fact that an artist is a *man*, so the motto *Art for the people* simply disregards the world of art itself, and the values of the creative intellect, and the fact that an artist is an *artist*.

It is true that art finally serves the good of the human community—in a deep and mysterious sense, that I shall try to indicate at the end of this chapter. But the error consists in misunderstanding and misusing this true notion

and believing accordingly that the social or moral value of the work must enter the very sphere of the making as its supreme standard.

At this point a little more searching analysis seems relevant. I have said that any human intention or purpose whatsoever may incite the artist on condition that the movement of his art toward the work does not deviate, and that his art is strong enough to keep its autonomy in its own sphere.

How is this possible? How can art's autonomy remain intact under such an incitation?

In two ways, I think. *Either* because the human end intended remains completely extrinsic to the domain of art's activity, as the wages are for a worker, or the royalties for a writer, or success for any artist. *Or* because that which moves the artist is fully integrated with his own creative subjectivity and creative experience.

I would say that what we call in French *la commande*, the fact of the artist being commissioned to do a certain task, by some patron, prince or wealthy art fancier, falls in the category of the first case. Here we have a problem posed for the artist from the outside; it delimits the subject matter, but only the creative activity of the artist solves it. Paul Valéry asserted that nothing would please him more than being commissioned to write a poem of a given number of lines and even of words, and even of letters. Under such circumstances the craftsmanship of a watchmaker would display all its power; and Valéry dreamed of being a perfect watchmaker.

In the other case, when the poet obeys an idea or a passion which is dear to him—especially a passion or an idea as remote in itself from spiritual creativity as a *social* idea or a *social* passion is—there is, no doubt, a risk involved, because such a passion or idea, while taking part in the operation of art, remains, as long as it has not been integrated in creative experience or intuitive emotion, a factor external to art, and thus risks superseding the requirements of art or preying upon them. Thus it is that it is bad luck, as a rule, for a poet to become a *national* poet: though in certain instances good poems have been written under the fire of national or even political passion. But in these instances—and this is my point—the passion in question had been internalized in the creative source, integrated in the poetic intuition, and therefore transmuted; for then, once it has been thus integrated in poetic intuition, what had been an idea or a passion has become poetic knowledge. There is no longer a passion, or an idea participating in the management of the making, there is poetic knowledge, inspiring *all* the management of the making. And this is all the more true as we have to do with more universal and all-pervading passions, ideas or beliefs: religious, philosophical, metaphysical, or with the unified intellectual and cultural universe that a Dante, a Donne, or a Shakespeare carried in his mind. All these human riches were in these poets, when they were at work, in the state of poetic fire or creative intuition.

I would submit that in the two cases I have just delineated only the virtue of art commands, and nothing else intervenes. In the first case, in the case of *la commande*, it is because the

end intended by the artist or the conditions imposed upon him remain entirely *outside*. In the second case, in the case of the idea or passion fully integrated in creative emotion, it is because the human impulse or motion *does not need to enter:* it is *in* from the start, being one with the poetic intuition which animates the virtue of art and passes through it, and which all the rules of the making have to obey. Thus the autonomy of art is not impaired; it is, on the contrary, increased and fortified, for the influence exercised on it is like that of the sun and the climate on a plant, and the *motion* it receives acts from within and passes into it in the manner of an inspiration.

*

But the theory of *Art for the social group* is not concerned with such problems or with the notion of the autonomy of art. It simply ignores this autonomy; it makes the *social value*, or *social significance*, or *social impact* of the work into an aesthetic or artistic value, even the supreme aesthetic or artistic value. According to this theory, a good which is not the good of the work, but a certain good of human life, is made into the very object, essential and intrinsic, determining and specifying, of the very virtue of art. One believes that the work must be ruled and shaped and brought into being *not* with regard to the creative intuition in which it originates and the rules of making which it calls for, *but* with regard to some moral or social requirements to be satisfied; one believes that the work must be immediately touched

and attained, in its very making, by judgments and determinations which depend not on the virtue of art but on emotions, purposes or interests of the moral or social order. To this very extent art is warped and bent to the service of a master who is not its only genuine master, namely the work, its true object, in the service of which it achieves its own inalienable freedom. *Art for the social group* becomes, thus, inevitably propaganda art. What the existentialist fashion calls today engaged art, "l'art engagé"—we might say as well enlisted art, or drafted art—is, inevitably, propaganda art, either for moral or anti-moral, social, political or philosophical, religious or anti-religious purpose. An artist who yields to this craving for regimentation fails by the same token in his gifts, in his calling and in his proper virtue.

Art, like knowledge, is appendent to values which are independent of the interests, even the noblest interests, of human life, for they are values of the intellectual order. Poets do not come on the stage after dinner, to afford ladies and gentlemen previously satiated with terrestrial food the intoxication of pleasures which are of no consequence. But neither are they waiters who provide them with the bread of existentialist nausea, Marxist dialectics or traditional morality, the beef of political realism or idealism and the ice-cream of philanthropy. They provide mankind with a spiritual food, which is intuitive experience, revelation and beauty: for man, as I said in my youth, is an animal who lives on transcendentals. Plato, the Plato of the Republic, held poets to be deceptive imitators of imitations, pernicious to the city, its truths and its morals. At least he was fair to

them in expelling them from the state. He knew that poetry, as long as it remains poetry, will never and can never become an instrument of the State.

*

Yet the theory of *art for the social community*, which I just criticized, arose, as a matter of fact, from the very excess of the theory of *Art for Art's sake*. The system and practice of the complete irresponsibility of the artist, who writes freely only if he is sure that it does not matter what he writes, runs, as we have seen, against the grain of nature. A reaction from the social community was inevitable. People cannot indefinitely bear to have their basic standards and beliefs mocked or undermined, their moral heritage threatened, their own minds confused or their imaginations poisoned for the sake of the artist's irresponsibility. These reactions can be dull and queer, philistine, misguided or simply coarse. They are a phenomenon of natural, so to speak biological defense. I read some years ago a press release whose authenticity I don't vouch for, but which at least had punch in it. The story was that the workers in a printing office had refused to print the manuscript of a most talented writer—a man whose prose is impeccable—because they were revolted by its lewdness. If the story is true, such a spontaneous reaction was quite symptomatic.

I wonder, nevertheless, whether a spontaneous censorship by the printers, if it were to spread, would be particularly commendable, both with respect to art itself and finally to

the common good. Indeed, if we give free rein to our imagination, may we not visualize, in a kind of nightmare, the possibility of a more general phenomenon, namely a revolt of the so-called common man against the intelligentsia at large, whose irresponsible achievements have put everything in jeopardy? Let us kill the physicists with their atom-bombs, the biologists with their biological warfare, the philosophers with their Babel of queries, the professors with their atomizing of human brains, the newspapermen with their maddening thrills, modern painters with their rabid distortions, modern novelists and poets with their *it does not matter what we write?* There was something of such a revolt against intelligence, and yearning for barbarism, in a certain worshipping of "life" and todayism of "the people" in Nazi Germany.

The kind of nightmare I just imagined has no chance of becoming a reality—not, I think, because people lack the resentment involved, but because they lack, fortunately, the power of satisfying it in this way. Yet a worse reality can confront mankind. People have no power, but totalitarian States do have power to enforce the control of morality—their own peculiar morality—over the workings of the intellect, especially over art and poetry. Then, as Hitler's regime and Stalin's regime have shown, creative activities are accountable to the State and subservient to the State; the artist and the writer have a primary moral obligation toward politics; they must also comply with the aesthetic tenets set forth by the State which claims to express and protect the

needs of the people. The State does not expel Homer, as Plato naively wanted. It tries to domesticate him.

2.

Is there, then, a solution to the problem? I believe there is; and here, as in all other instances, we are not condemned to choose between anarchism and totalitarianism. But this solution cannot sweep away all possibility of tension and conflict. On the contrary, it makes capital out of them, as whenever two freedoms meet and have to adjust to one another.

As concerns the human community, we have to recognize that freedom of expression and freedom of art are not those absolute and limitless, divine rights which XIXth century anarchistic liberalism enthroned. They are natural rights in the sense that they answer natural aspirations of thought and creative activity. But they are not absolute and limitless in nature. It is not true that every thought or artifact as such, poisonous as it may be, has, because of the mere fact that it was born of a human mind, an absolute right to be displayed in the human community. As Thomas Aquinas put it,[1] if an art produces objects which men cannot use without committing sin, idols for idolatry for instance, or—he might have said, if he had lived in the time of la marquise de Brinvilliers —poisoned bouquets for murder, it is only normal to make the trade of idols or of poisoned bouquets impossible.

Yet it is with the art of the writer that we are dealing, and

[1] *Sum. theol.*, II-II, 169, 2, and 4.

writers do not contrive, at least as the specific object of their art, idols or poisoned bouquets. Writers are concerned with ideas and they communicate ideas. So it is necessary to go more closely into the question.

Let us read for this purpose article Nineteen in the Universal Declaration of the Rights of Man proclaimed by the United Nations in December 1948. I think that this article was written by some exceedingly shrewd or exceedingly lucky jurist, for it appears simple and self-evident, and yet it implies an unexpressed though quite serious *No* concealed behind a strong and glorious *Yes*.

This article reads: "Everyone has the right to freedom of opinion and expression; this right includes freedom to hold opinions without interference and to seek, receive and impart information and ideas through any media and regardless of frontiers."

To *impart ideas:* All the shrewdness—the unexpressed *No* together with the ringing *Yes*—is concentrated in this word *ideas*.

Freedom to impart or spread *ideas* is one with freedom of research and thought, which is a natural right of the mind, and manifests the superior dignity of thought with respect to the social community.[1]

[1] I am speaking of the *temporal* social community, whose common good is neither divine truth nor the internal virtue and perfection of souls, but pertains to the practical order, and tends to the highest possible point, under given circumstances, of moral decency, justice, civic friendship, freedom, peace, progress and prosperity in life in common. It is only with the temporal social community (civil society and State) that the present discussion is concerned; and it is only

But freedom to impart ideas is not freedom to undertake or exercise *actions,* for actions can be repressed if they tend to destroy the foundations of life in common. It is obvious that the social community has a right to defend itself against such actions, for instance an attempt to overthrow freedom by violence or to organize crime and murder.

Such a distinction is obvious and necessary. But its applica-

with respect to it that the distinction I am emphasizing here between *ideas* as such and *actions* makes sense.

When it comes to that supernatural society which is the Church, whose common good is divine truth communicated to men and the inner life of grace vivifying them, the situation is quite different. Obviously such a society has to be concerned with ideas, insofar as they relate to revealed truth and inner morality, and it has a right to oppose with its own spiritual sanctions ideas which are destructive of the one or the other.

This is indeed, at least in the eyes of those who are in communion with the faith of the Church, more of an assistance than of a limitation to freedom of research, because attention to and respect for an authority which is authentically spiritual and committed to truth, can, of itself, only help and fortify us in our quest for truth. As to possible accidents—I mean the possibility (in those cases where the infallibility of the Church is not at play) of having right ideas mistakenly opposed—such a possibility has proved for centuries to be, as a matter of fact, more often than not a stimulus for research: given the assurance, of which every believer is possessed, that in the long run every bit of truth will be recognized and honored by a society which is the body of Christ and whose very life is divine truth.

On the Catholic positions on censorship, see Charles Journet, *The Church of the Word Incarnate,* London and New York, Sheed and Ward, 1954, t. I, ch. VII (with regard to the jurisdictional power of the Church), and *Exigences chrétiennes en politique,* Paris, Egloff, 1945, table alphabétique, "Censure" (with regard to the limitations of state censorship); Harold C. Gardiner, S.J., *Catholic Viewpoint on Censorship,* New York, Doubleday, 1958, and "The Catholic as Censor," a review of Father Gardiner's book by William Clancy (*The Commonweal,* May 9, 1958).

tion is not without risks and difficulties. For the use of *ideas* can itself aim at *action*.

At this point we must be quite careful in our analysis. I am not referring to the fact that all great ideas, including (and chiefly) the most abstract and theoretical ones, are laden with a tremendous implicit power of action. It is so with philosophical systems, with the successive scientific images of the world, with great literary works. If by reason of this fact, and by reason of the practical consequences that can be expected from a work, the social group had a right to forbid a man to "impart" his "ideas," freedom of expression would simply vanish. It is on such grounds that Socrates was condemned, and that Frederick the Great turned an indignant eye on Kant's categorical imperative, it being of a nature to lead his grenadiers astray. Let it be noted parenthetically that such behavior on the part of the social authority is only logical according to Marxist theory, where thought is by nature *praxis* or action.

The distinction I am pointing out does not refer to the greater or lesser power of action which is involved in an idea. It refers to the fact that the use of ideas corresponds to two obviously distinct functions and purposes. Either the use of ideas is directed toward the search for knowledge or expression of creative experience, and belongs to the field of Thought or Idea proper—or the use of ideas is directed toward bringing about, here and now, a given practical effect, and belongs to the field of Action and incitation to action. Hence inevitable conflicts. Suppose that a political lunatic publishes pamphlets in which he advocates the mass-

murder of Jews or the destruction of the incurably ill, who are a burden to the community (this was not a hypothetical example at the time of Nazi Germany)—or suppose that a religious lunatic prints papers inciting his fellow sectarians to collective suicide (this was not an inconceivable example at the time of the Old-Believers Sect in Russia). These men will claim freedom to express and impart their *ideas*. But the social community and its various groups are directly interested in those *incitations to action*, and they would be foolish not to oppose them by some appropriate means—means which would not involve open and official censorship, if the community hated the very name of censorship, or would reduce it to a minimum, but which would constitute for all that efficacious prohibitive devices.

Difficult and risky in application as it may be, the distinction is grounded in reality, and necessary. When it comes to the *moral* or *immoral* value of a literary work, the community may have to guard its standards against it to the extent that it is an *incitation to action*. The problem is simple in the case of the products of the pornographic industry— they deal with conditioned reflexes, not with ideas. But it becomes quite entangled when it is a question of literary works properly speaking, in which a hope to awaken some unavowable complicity or an open disregard of accepted standards is involved, either in a more or less spurious or in a genuine or even superior spiritual creativity. We cannot deny that people who are not specialists in literature have a right to be warned against reading authors whose artistic talent is but a means to unburden their vices and obsessions

on us. On the other hand we cannot deny that the attempts of the State to condemn *Les Fleurs du mal* or *Madame Bovary* or any other great work are themselves condemned to failure and succeed chiefly in making the State look ridiculous.

*

The fact remains that, in the sense in which I have been arguing and for the reasons I have tried to make clear, certain limitations on the exercise of freedom of expression are both inevitable in actual existence and justifiable in themselves. But there is no clear objective borderline between the two domains which we have distinguished, so that the quarrel between the moral interests of the community and the aesthetic interests of the artist will never cease. In actual fact the application of our distinction is only a matter of prudent or wise practical judgment. At this point let me emphasize the fact that the only reason for limitations being brought to bear on freedom of expression is the common good of the human community. And because this common good is the common good of human persons, it implies as an essential part *a respect* for intellectual values, dealing with truth and beauty, which are supra-political in nature; *a respect* for freedom of inquiry, which is a basic right of the human person; and *a respect* for the inner energies of intelligence and conscience, which are the mainsprings of social and political life, and which cannot be coerced, but can adhere only to what they have good reasons to believe true. The

common good is ruined if the human community ignores these three kinds of respect. And so it is in the very name of the common good that any limitations which may legitimately be brought to bear on freedom of expression and freedom of art should always respect the basic freedom and dignity of the intellect and be calculated to foster, not impair them.

Shall I indicate briefly some of the practical conclusions which derive from this principle? Let us remember first the distinction which must be made between the *social community* and the *State*. The State is but a part, the topmost part but a part, of the social community or the body politic. And the effort to protect the human society from the pernicious actions or incitations to action possibly conveyed by a work is the job of the social community more than of the State. The first responsibility rests on the social community as distinct from the State.

The first way for the human community to confront the risks of possible drawbacks resulting from freedom of expression and freedom of art is education, which equips the mind with vital powers of resistance, criticism and discrimination. In the second place, there is the spontaneous pressure of the common consciousness and public opinion, springing from the national ethos when it is firmly established. In the third place there is the pressure which results from the fact that large groups of citizens may warn their members against reading a book or seeing a moving picture (even if it is a question of great works, for everything depends here on the moral standards, the intellectual preparation, the degree of moral solidity and the age of the strata of population in-

volved). And in the fourth place there is the activity of the various private groups and organizations which, freely starting from the bottom and uniting on the one hand readers or listeners, on the other writers or speakers, should develop, as regards the use of the media of mass communication, a ceaseless process of self-regulation as well as a growing sense of responsibility.

As regards the State, its right, which cannot be denied, to intervene in the field of artistic creativity and of the expression of thought, demands, I think, to be applied in a most limited way. And since the common agreement on the basic tenets of a free society is itself merely practical, the criterion for any interference of the State should be of a merely practical, not ideological nature. The more extraneous this criterion is to the very content of thought or to the inner value of the work the better it will be. It is too much for the State to judge, for instance, whether a work of art is possessed of an intrinsic quality of immorality (then it would condemn Baudelaire or Joyce); it is enough for it to judge whether an author or a publisher plans to make money by selling obscenities, or inducing civil discord, or circulating libel. Why such restrictions on the exercise of the rights of the State? Because the fact is that the State is not equipped to deal with matters of intelligence. Each time the State disregards this basic truth, intelligence is victimized. And since intelligence always has its revenge, it is the social body and the human community which, one way or another, are victimized in the end.[1]

[1] Cf. our book *Man and the State*, The University of Chicago Press, 1951, p. 118.

Finally, among the various external means we are now considering, the function exercised by free discussion and criticism is the most natural one: for then it is the very freedom of expression of thought and of artistic activity which counteracts the possible drawbacks of artistic activity. At this point I would like to emphasize that the literary critic and the creative writer are in reality the same person in two different functions. A critic in science or in philosophy is a scientist or a philosopher; a critic in poetry is a poet—sometimes paralyzed as to the creative work by an excessive development of the reflective faculties, but fundamentally a poet. Thus in criticism we have art itself freely and rationally discussing and regulating art. And criticism has a double function: first to judge the work for the sake of art and aesthetic values; and second, to point out, for the sake of the human community, the moral implications contained in the work. Thomas Aquinas warned teachers "never to dig" in the path of the student "a pit that you fail to fill up." The same can be said of critics with respect to the reader. The task of genuine criticism is a task of ceaseless purification and enlightenment, first as regards the creative activity itself of the artist, second as regards the common consciousness of the people.

3.

Thus the key to our problem—as concerns the possible interference of the social community restricting from the outside the free expression of literary or artistic activity, or

more exactly, the free circulation of its products, through some spontaneous pressure or even through more or less coercive means—the key to our problem is a *true sense of the common good,* and of the respect for intelligence and conscience that the common good basically requires.

Now I should like to point out that this true sense of the common good has with regard to art and poetry (and now I am speaking of art in general, not only of literature) much wider and far-reaching implications. For a true sense of the common good understands that Art and Poetry, though or rather *because* they deal with an object independent in itself of the rules and standards of human life and the human community, play an essential and indispensable part in the existence of mankind. Man cannot live a genuine human life except by participating to some extent in the supra-human life of the spirit, or of what is eternal in him. He needs all the more desperately poets and poetry as they keep aloof from the sad business and standards of the rational animal's maintenance and guidance, and give testimony to the freedom of the spirit. It is precisely to the extent to which poetry is useless and *disengaged* that poetry is necessary, because it brings to men a vision of reality-beyond-reality, an experience of the secret meanings of things, an obscure insight into the universe of beauty, without which men could neither live nor live morally. For, as St. Thomas put it, "nobody can do without delectation for long. That is why he who is deprived of spiritual delectations goes over to the carnal."[1] And St. Theresa of Avila used to say that

[1] *Sum. theol.,* II-II, 35, 4, and 2.

even for contemplatives, if there were no poetry life would not be tolerable. Leave, then, the artist to his art: he serves the community better than the engineer or the tradesman.

At this point I should like to quote a passage from Shelley's *Defense of Poetry*. After having claimed—which seems quite questionable—that "the greatest poets have been men of the most spotless virtue," Shelley cannot help realizing that such has not always been the case. Then he projects himself, through an oratorical movement, to the opposite extreme in the manner of a concession to the vulgar. "Let us for a moment, he says, stoop to the arbitration of popular breath . . . Let us assume that Homer was a drunkard, that Virgil was a flatterer, that Horace was a coward, that Tasso was a madman, that Lord Bacon was a peculator, that Raphael was a libertine, that Spenser was a poet laureate. It is inconsistent with this division of our subject to cite living poets, but posterity has done ample justice to the great names now referred to. Their errors have been weighed and found to have been dust in the balance; if their sins 'were as scarlet, they are now white as snow'; *they have been washed in the blood of the mediator and redeemer, Time.*"[1]

A poet who counted upon this kind of redeemer for his own salvation would be strangely mistaken. Time is not the redeemer of the poet's soul. But it is indeed the redeemer of the poet's work. In this sense Shelley is right and he forces us to confront a great truth.

*

[1] *The Great Critics*, edit. by J. H. Smith and E. W. Parks, p. 501 (Italics ours).

I would say that the common good of mankind is as indifferent as Art itself is to the personal destiny of the poet and to his good—temporal or eternal—as a man. Let him incur damnation, if only his work enriches the spiritual treasure of the world. The poet is alone, alone with God, as every man is, in the management of his own destiny. Neither his art nor the generations which will live on him are of any help.

In the realm of the earthly destiny of the work, in the realm of the world, or of civilization, not only are the sins of poets washed in the blood of Time, but also the possibly sinful impact of their works.

The statues of Greek gods no longer wound human souls with the arrows of idolatry. They have lost their magical and bewitching power. Only beauty remains. In poems like those of Baudelaire or Lautréamont, or in the novels in which Proust makes an ambiguous confession, the moral impact through which human souls may possibly be wounded is blurred and extinguished by Time—only some deeper revelation of the heart of man remains. The clearest result of the work of Baudelaire has been to turn modern poetry toward the universe of the spirit, and to awaken in men a theological sense.

Here again Shelley was right in insisting that "whatever strengthens and purifies the affections, enlarges the imagination, and adds spirit to sense, is useful"—useful with the utility of what is beyond utility. And Shelley also wrote: "All high poetry is infinite; it is as the first acorn, which contained all oaks potentially. Veil after veil may be undrawn, and the inmost naked beauty of the meaning never exposed.

A great poem is a fountain for ever overflowing with the waters of wisdom and delight; and after one person and one age has exhausted all its divine effluence which their peculiar relations enable them to share, another and yet another succeeds, and new relations are ever developed, the source of an unforeseen and an unconceived delight."[1]

I would submit that as concerns the final contribution of art to the common good of the human race, not only in relation to the fact that man cannot do without poetry, but also in relation to the progress of moral conscience itself, what essentially matters is the *depth* of the creative experience, the depth of the creative source. For in the long run any deeper awareness of what is hidden in man turns to a greater enlightenment of moral conscience. Here we are confronted with the most real and mysterious sense in which art serves the community—in its very freedom from the interests of the social group.

With respect to the perfection of life of the poet himself, and to the immediate moral impact of his work, Mauriac's remark holds true; the only way is to "purify the source."

But with respect to that final impact on the common good of mankind of which we are now speaking, it is not the purity of the source, it is rather its depth, it is the inner depth of the experience from which it springs which is of primary importance in actual fact.

Perhaps this explains why, scarlet as the sins of the poet may have been, odious perhaps as he may have been as a

[1] *Ibid.,* p. 575.

man, we love him nevertheless, because he was a poet, and we are grateful to him, not only as lovers of beauty, but also as men concerned with the mystery of their own destiny; and he is white as snow to our eyes—in his work. In any case we do not have to judge him. God will work that out with him, somehow or other.

<p style="text-align:center">4.</p>

I have a few words to add to conclude this chapter. Theorists in aesthetics are usually concerned with the role of art in reference to the human community. But they should also be concerned with the role of the human community in reference to art. Since the community needs art and the artists, the community has certain duties toward them. Just as the writer must be responsible, so must the community.

In actual fact what the artist, the poet, the composer, the playwright expects from his fellowmen, as a normal condition of development for his own effort, is to be listened to, I mean intelligently, to get a response, I mean an active and generous one, to have them cooperate with him in this way, and to feel himself in a certain communion with them, instead of being confined, as happens so often nowadays, in an intellectual ghetto.

This means that the primary duty of the human community toward art is to respect it and its spiritual dignity, and to be interested in its living process of creation and discovery. It is no more easy nor arbitrary to judge a work

of art than to judge a work of science or philosophy. A work of art conveys to us that spiritual treasure which is the artist's own singular truth, for the sake of which he risks everything and to which he must be heroically faithful. We should judge of it as the living vehicle of this hidden truth; and the first condition for such a judgment is a kind of previous *consent* to the intentions of the artist and to the creative perspectives in which he is placed. In judging of the artistic achievements of their contemporaries, people have a responsibility, both toward the artist and toward themselves, insofar as they need poetry and beauty. They should be aware of this responsibility.

Chapter IV

Poetry and Perfection of Human Life

Chapter IV

Poetry and Perfection of Human Life

I.

IN THE previous chapter I discussed the responsibility of the artist in relation to the human community. The topic of this final chapter deals with the responsibility of the artist, no longer to other men, but to himself. In other words, what we have to consider is the relationship between art and moral life *within* the poet himself, or the inner connection between his effort toward the *perfection of the work* and his effort, if he makes any, toward the *perfection of human life.*

I have insisted all along that the aim which art directly intends and which makes art what it is—that is to say, as the Schoolmen put it, the *formal object* of Art—is not subordinate in itself to the *formal object* of morality. It must be added—I already touched upon this point, but I would like to make it more explicit now—that not only the order of *formal causality*, or the perspective of essences taken in themselves, but also the order of *material causality*, or the perspective of the concrete subject in which the essences of various qualities exist together, must be taken into consideration.

Ethical realities are of essential importance for the artist

inasmuch as he is a man, to be sure; but in concrete life they are of importance for him not only inasmuch as he is a man, they are also of importance for him—though, this time, in a so to speak accidental manner—inasmuch as he is an artist, or with respect to the very achievement of his virtue of art. From the fact that art exists in man, moral realities, which concern the artist as man, have also, in addition, a certain impact on him as an artist. In other words morality has to do with the virtue of art in the order of *material* or *dispositive* causality. Since this connection pertains to the order of material causality, it is only *extrinsic and indirect* and subject to any kind of contingency, and it can be at play in various, even opposite directions. Yet, extrinsic and indirect as it may be, it is altogether real and inevitable.

The highest moral virtues can never make up for the lack or mediocrity of the virtue of art. But it is clear that laziness, cowardice or self-complacency, which are moral vices, are a bad soil for the exercise of artistic activity. The moral constitution of the human subject has some kind of indirect impact on his art. "No enmity of outward circumstances, but his own nature, was responsible for Shelley's doom," Francis Thompson sternly wrote.[1] A certain lack of moral and psychological integration, and, as a result, a certain split between sensibility and the creative power of the intellect or imagination, contributed in some way both to the particular beauty and to the deficiencies of Poe's or Hart Crane's poetry. A moral poison which warps in the long

[1] "Essay on Shelley" (1889), *Works*, London: Burns and Oates, 1913, vol. III, p. 16.

run the power of vision will finally, through an indirect repercussion, warp artistic creativity—though perhaps this poison will have stimulated or sensitized it for a time. At long last the work always *avows*. When it is a question of great poets, this kind of avowal does not prevent the work from being great and treasurable, yet it points to some soft spot in this greatness.

Furthermore, are not the inner inclinations of the artist the very channel through which things are revealed to him? Is it not in and through himself, through his own emotion and subjectivity, that the poet, in so far as poetic intuition is concerned, knows everything he knows? What is most real in the world thus escapes the notice of a darkened soul. Let us remember Plotinus' remark in this connection. "Just as one can say nothing about the beauties of senses," he wrote, "if one has no eyes to perceive them, so it is with the things of the spirit, if one cannot see how beautiful is the face of justice or temperance, and that neither the morning star nor the evening star is so beautiful."[1] We may understand in this respect why a number of novelists think that "only the marshes are fecund."[2] In any case the work is always nourished by the experience of the man.

Yet the problem we are now considering is still more complicated, because of the fact that the artist is aware of the very impact I just pointed out of his own moral life on his art. Thus he may be tempted to develop, for the sake of

[1] *Enneads*, I, 4.
[2] This was a saying of André Gide.

his art, a certain conception of moral life itself, or of moral heroism, a certain system of moral values and moral standards and moral imperatives—all that directed to the good of his work, not of his soul. That's what I would call the temptation of a *merely artistic morality*. I think that the part played in this regard by Walter Pater and Oscar Wilde in the last century was not insignificant.

Sometimes poetry is depicted as forcing upon man moral obligations the burden of which can never be set down. "We shelter in ourselves an Angel whom we constantly shock," Cocteau said.[1] "We must be the guardians of this angel." Sometimes an artist speaks of the requirements of ethics and purity and self-sacrifice in more exacting terms than any moralist would.

Yet let us be careful! The ethics of which we are being told will perhaps consist in regarding moral law as a plaster on an abscess, or wet paint on a dirty wall—mind the paint! it stains! What does not stain is the dunghill, because it is full of living ferments. Self-sacrifice will perhaps consist in attempting with one's own soul and body and with the destiny of other human beings any new experiment apt to reveal new human horizons, and in heroically plunging into evil in order to redeem it by poetry.

Such a merely artistic morality or merely artistic system of life is less an articulate doctrine than a practical cast of mind, sporadically developed in a few circles. I would not ascribe to it more consistency than it has. Let me say, nevertheless, that it seems to lay stress on three main virtues of its

[1] In his book *Le Coq et l'Arlequin.*

own: a certain type of sincerity, a certain type of purity, and imperious curiosity.

There is of course a sincerity which is a genuine virtue. I would say that it is not only sincerity with respect to others, but first of all sincerity with respect to oneself—the sincerity of the knowledge with which a man penetrates into his own interior life: a straightforward, merciless gaze before which the heart spreads like open country, and for which the shames, the social prohibitions and all rules concerning the dialogue with others, are not transferred into the secret colloquy in which God alone takes part, and do not dissimulate anything of what exists in our inner recesses. But the sincerity of merely artistic morality is another kind of sincerity: the sincerity of matter as available to any form. It consists not in *seeing* oneself, but in *accepting* or cherishing oneself at each moment just as one is, and refusing to make any choice or moral decision: for this would risk preventing the potentialities of the Ego from freely developing —both toward God and toward the devil—and its various aspects to be manifested in the work regarded as a sort of self-epiphany. Gide wrote, at one and the same time, by dint of sincerity, a book expressing a most scrupulous love for the Gospel and a book preaching homosexuality.

As concerns purity, as this merely artistic morality sees it, we might say that it resembles the purity of plants, which, as Aristotle said, having only a vegetative soul, live in perpetual sleep, without being troubled by reason, and have all their aim in the flower. They have their mouth in the

earth, and they expose their sex and corolla to the birds of heaven, without any repression. Purity consists in behaving as if evil did not exist. What is *pure* is a human act that the distinction between good and evil does not even graze, and which no moral standard risks distorting. A crime, a vice, a lie, malice or lust, all this is *pure* if it is intact, if no turn of reason judges it and interrupts its movement, if it keeps its virginity for poetry.[1]

Curiosity finally is the supreme ethical virtue, because it is the motive power which makes an artist take any risk and confront any disaster, for himself and for others, in order to discover new secrets in things, and first of all in himself. Thus he wants to taste all the fruits and silts of the earth, and to be fully instructed by the experience of evil, in order to feed his art.

To sum up, on the ground that art reflects morality, one insists that art exacts a life which is morally dangerous, and new experiments in morality as in aesthetics—that is to say experiments to render innocent, thanks to the sorcery of poetry, the very things God forbids. This means, if you like, subordinating art to morality, but to a morality that art has violated.

As regards the work and the artistic result, who can know whether the work would have been better or worse if a given artist had not yielded, to some extent or other, to the seduction of merely artistic morality, and had led a life more true to the requirements of moral law?

[1] Cf. "Dialogues," in our book *Art and Poetry* (New York, Philosophical Library, 1943), pp. 43-44.

2.

What is, then, the truth of the matter? About the relationship between art or poetry and genuine morality, or the true perfection of human life, I should like to submit three tentative remarks, regarding first *the impact of a moral change in the artist* on his art and his work; second, *the aesthetic virtues;* and third, *poetic experience.*

In the order of *formal causality*—moral virtues, as we have seen, belong to another sphere than the sphere of art, and are of no use to it. In the order of *material causality*, moral virtues—and, more perhaps than them, what may be called the *premoral dispositions*, deeply rooted in the psychological constitution of the human being, and, still more, the supreme love to which a man makes his life appendent—have an indirect repercussion on the virtue of art. Now, what about the case where an artist, suddenly awakened to the problem of his own destiny, changes his moral life and turns it toward the moral good? Does the fact that the man becomes better necessarily make his work better also?

I said in my previous chapter that this is a melancholy problem: for, as a matter of fact, it happens that the work may become worse. Religious conversion does not always have a favorable repercussion on the work of artists, especially minor artists.

The reason for this is obvious. For a number of years the inmost experience from which the inspiration of a given artist arose was a dark experience fostered by some sinful ardor, and revealing to him corresponding aspects in things.

His work made capital out of all that. Now his heart is puri-
fied, but his new experience is still weak and, as it were,
childlike. He has lost his inspiration of former days. And at
the same time great moral ideas, newly revealed to him,
and of major importance in themselves, occupy his intellect.
Will they not prey upon his art as substitutes for insuffi-
ciently deep experience and creative intuition? The risk is
serious for the work.

Some extraneous elements make it still greater, because
religion offers to the artist a double temptation of facility.
On the one hand—religious feelings being lofty and beauti-
ful emotions—he may be tempted to satisfy himself in
expressing his emotions as subject matter or psychological
phenomena (which is the opposite of obeying intuitive or
creative emotion). On the other hand, community of faith
puts him in immediate communion with his fellow-believers,
and here again he may be tempted to substitute this easy
communion for that communication, more dearly paid, or
even that solitary expression of poetic intuition which art
alone can provide.

Well, we must realize that all that is accidental. None of
these unfortunate drawbacks would have come about if the
artist in question had been possessed of a greater and stronger
virtue of art, if he had understood that his very faith re-
quested him to be more exacting in his art and a more
attentive guardian of this Angel within him, and especially
if he had been more patient, and had asked Time, the re-
deemer of the work, to make his new experience and in-
spiration deeper and more mature, more comprehensive and

more integrated. Neither the work of Francis Thompson, Hopkins, Chesterton or T. S. Eliot, nor that of Léon Bloy, Claudel, Sigrid Undset, Gertrud von Le Fort, Bernanos, Julian Green, Mauriac or Max Jacob have been impaired by their faith and the fact of what can be called, in one sense or another, their conversion to God.

My second remark deals with the virtues which Art and Poetry demand in their own sphere, and which may be termed *aesthetic virtues*.

The artist is subject in the sphere of his art to a kind of asceticism, which may require heroic sacrifices, I mean this time genuine heroic sacrifices. He must be always on his guard not only against the vulgar attractions of easy execution and success, but against a host of more subtle temptations. He must pass through spiritual nights, purify his ways ceaselessly, voluntarily abandon fertile places for barren regions full of insecurity. In a certain sphere and from a particular point of view, in the sphere of the making and from the point of view of the good of the work, he must possess humility and magnanimity, prudence, integrity, fortitude, temperance, simplicity, ingenuousness. All these virtues which the heroes in spiritual life possess *purely and simply*, and in the line of the supreme good, the artist must have *in a certain relation*, and in a line apart, the line of the work. His virtues as an artist *imitate*—they *are* not—the virtues of man as a man. Most poets, probably, like most saints"—Francis Thompson wrote—"are prepared for their mission by an initial segregation, as the seed is buried to

germinate: before they can utter the oracle of poetry, they must first be divided from the body of men."[1]

I spoke a moment ago of the spurious purity of merely artistic morality superseding true morality. But in the sphere of art itself there is a genuine purity, which is concerned with the making of the work and the duty to remain true to creative intuition. The purity of the artist is an authentic purity, paid for by the weight of the sufferings of a created mind, and which is an emblem of a truer purity; and which, in emblematizing it, prepares it. In his *Art Poétique* Max Jacob asserted that the virtues required from the artist, especially the modern artist, are, as aesthetic, not moral virtues, evangelic in nature. "Voluntary poverty," he said, "is an aesthetic virtue. Soberness is an aesthetic virtue. Chastity is an aesthetic virtue. Respect is an aesthetic virtue." "Fortitude, renouncement, obedience, order, humility" are aesthetic virtues in the realm of art, as they are Christian virtues in the realm of moral life.

All this means that the virtues of the artist as an artist are in a relation of analogy with the virtues of man as a man, and more especially perhaps with Gospel virtues. With respect to man they are ambivalent. While going their way, they may replace, for the artist, human and Christian virtues properly speaking, or they may create in him a sort of appeal to these virtues. But it seems to me to be clear that, ambivalent as they may be, they are of themselves congenial, as it were, with the universe of genuine love and moral perfection. Naturally and spontaneously, if man were not divided

[1] "Essay on Shelley," *Works*, vol. III, p. 11.

unto himself, they would *incline* the poet toward their sister-virtues, and prepare him to listen to their music.

The same can be said about poetic experience. Poetry has its own spiritual mystery, by virtue of which it resembles and foreshadows a greater mystery, and symbolizes with grace-given gifts without penetrating into their domain. And poetry's spiritual mystery is available to Heaven and to Hell as well. Poetic experience is a brooding repose which takes place at the center of the soul and in which the world and the subjectivity are obscurely known together in a non-conceptual manner. This experience is not mystical experience. It is busy with the created world and the enigmatic relations of things with each other, not with the principle of things in its own supra-mundane unity. The obscure knowledge that it implies comes about through emotion, not through love of charity. Poetic experience is from the very start oriented toward expression, and terminates in a word uttered or a work produced, while mystical experience tends toward silence, and terminates in an immanent fruition of the absolute.

But different in nature as they may be, poetic experience and mystical experience are born near one another, and there is between them a kind of congeniality.[1] As a result of some basic choice accomplished in the heart of man, poetic experience can either *mimic* or *call for* mystical ex-

[1] Cf. Raissa Maritain, "Sense and Non-Sense in Poetry," and "Magic, Poetry, and Mysticism," in *The Situation of Poetry*, translated by Marshall Suther, New York: Philosophical Library, 1955, pp. 17-22 and 31-36.

perience. Either it may turn the poet toward that ecstasy of the void and nothingness and that enticement of magic which Mallarmé and some other poets and still more the surrealists have experienced. Or it may turn the poet toward God-given mystical experience. And of itself, naturally and spontaneously, it is for this genuine spiritual contemplation that poetic experience would obscurely predispose the poet, if man were not divided unto himself, and if he did not at times warp poetic experience through some egotistic yearning for power.

3.

I am afraid I can propose only inadequate views on the problem I must discuss in the last part of this essay, for competence in such a problem would require experience more than theory. Yet, willy nilly, I am obliged by my subject-matter, and by poets themselves, to tackle this problem, the problem of Art and the Perfection of human life.

Not to speak of Michelangelo or Racine, of Henry Vaughan or George Herbert, this problem worried many great artists, at least as long as poets and writers were not induced to make themselves into the prophets and the saints of the modern world. Some contemporary novelists have been led, under the pressure of their inner difficulties and conflicts as men dedicated to literary work, to pose the problem in the most decisive terms.

Let us think of the particular situation of the novelist with respect to his work. He is a kind of god muddled with

the weaknesses of man. He deals with a world of characters whom he creates but who are sometimes stronger than himself, and whom he knows through himself but whose freedom is an imaginary freedom: unlike God, he is the author of the evil committed by his creatures. And this imaginary evil, in which the novel is seated, just as our real world is "seated in wickedness," as St. John puts it,[1] is in a strange intimacy with the real evil of our real world—it is an image and sign of this real evil, but an operative sign, which may, as occasion arises, stir in actual existence that which it represents.

Dealing with this particular situation of the novelist, and the relationship between his work on the one hand, and, on the other hand, his own soul and the souls of others, but especially his own soul, Mauriac wrote: "Il faudrait être un saint ... Mais alors on n'écrirait pas de roman."[2] "One would have to be a saint. But then one would not write novels."

Thus the question is posed by Mauriac in terms of the supreme perfection of human life, or of *sainthood*. For Léon Bloy it was obviously posed in these terms. "If Art is part of my baggage," he said, "so much the worse for me! My only recourse is the expedient of placing at the service of Truth what has been given me by the Father of Lies."[3] To one degree or another, we find the same sort of anxiety in Bernanos, in Graham Greene, still more in Julian Green. Among critics Charles Du Bos was very much concerned

[1] I John, v, 19.
[2] François Mauriac, *Le Roman*, p. 80.
[3] "La Femme Pauvre" (*Pilgrim of the Absolute*. Excerpts selected by Raissa Maritain. New York: Pantheon Books, 1947, p. 112.)

with the problem. Charles Morgan, in a chapter of his book *The Liberties of the Mind,* also touched on it, though he did not consider it in all its dimensions.

Well, Mauriac's statement is one of those statements which seem cogent at first glance, but which, on further consideration, leave the mind in a state of perplexity. *One would have to be a saint. But then one would not write novels.* Cannot everybody say the same thing with regard to his own particular vocation in the world? *One would have to be a saint. But then one would not be a politician; one would not be a judge, a doctor, a banker, a businessman, a newspaperman, or anything here below,* save perhaps a monk, and still the job is not secure.

Every human occupation has its own hardships, entanglements or temptations which run against the perfection of human life. The question is: are the moral hardships and entanglements involved in the calling of an artist especially serious in this regard?

Yes, they are, in many respects. That's what the various points made in this essay prompt us to answer. I utterly disagree with the conclusion which is sometimes drawn from this fact. But the fact itself must be simply acknowledged.

First, the artist, in his most intimate creative activity, lives on the senses and the delights of the intelligence-permeated sense. It is through emotion that the world penetrates into him. He is sensitized to the world and all the vagrancies of beauty. As Léon Bloy puts it, "The artist's master faculty— the imagination—is naturally and passionately anarchic."[1]

[1] Léon Bloy, "Belluaires et Porchers" (*Pilgrim of the Absolute,* p. 106).

The poet is both a madman carried along by irrational inspiration and a craftsman exercising for his work the shrewdest operative reason. How could you expect from him that stable balance and constant attention to the rule of reason which perfection in moral life seems to require?

Second, when it comes especially to writers, they need to know the recesses of evil as well as those of the good in the human being, and not through an abstract and theoretical knowledge, as an author of treatises in moral theology does, but by experience and in concrete existence. Are they not obliged, then, in order to be good writers, to make the devil their assistant, at least on a part-time basis, and to seek after that experiential science of evil which is the privilege of sin?

In the third place, and this is a still more insidious problem, the novelist or the playwright knows his characters by means of that kind of knowledge which is called knowledge *through inclination or congeniality*—through the very passions, inclinations or instincts that he shares with his characters, even when he hates them with that lucid hate which makes a man know his enemy *as himself*. In other words his characters are virtual aspects or possible developments of himself—"Turelure, c'est moi," Claudel said one day. That's why the novelist is capable of foreseeing what his characters will do. Now is it possible to use such knowledge, especially in the total intimacy meant by creation—without entering into a kind of complicity or connivance with the imaginary being in question, and without suffering in oneself a repercussion of their own diseases or inferno?

I think that I have stated the difficulty in all its force.

What I am denying is not the factual situation on which these arguments rest, it is the conclusion that they claim to establish. Before trying to discuss them, I feel it is relevant to consider a little more closely the concept used by Mauriac when he said: *One would have to be a saint*, or by Léon Bloy when he said: *There is but one sadness, and that is for us not to be saints.*[1]

4.

The words of our language, especially the most important ones, both manifest and obscure the reality that they signify, because they remain laden with inevitable parasitical connotations. Christians have borrowed from Greek philosophers the word *contemplation*, to signify something utterly different from what Greek philosophers meant by the same word. The word *sainthood*, it seems to me, has similarly been laden by its past with possibly misleading accidental connotations. It was first used, in pre-Christian societies, in the sense of *sacred*, or *separate*, meaning a particular function— ritual or priestly—in the community. With Christianity the sense shifted from this particular social function—obviously reserved for a certain category of consecrated people—to the inner purity of the heart, and the internal separation from evil and internal dedication to God. This was a change of immense import. But something of the old meaning was to remain now and then accidentally. So, for many people in

[1] "Il n'y a qu'une tristesse, c'est de n'être pas *des saints*." Léon Bloy, "La Femme Pauvre" (*Pilgrim of the Absolute*, p. 301).

the baroque age it was an accepted opinion that, monks being dedicated to perfection, laymen are by the same token *dedicated* to *imperfection*, and would fail in their duty if they had higher aspirations than making themselves fit to be saved by the prayers of monks, especially by endowing monasteries with some pious foundations.

This happy division of labor was unfortunately heretical in nature. Christian sainthood is not a restricted resort. According to the Gospels and to Thomas Aquinas, it is a far-off goal toward which everyone must *tend* to the best of his ability. All right, but the word immediately met with a new misfortune, namely the canonization of saints. The connotation *canonized* or canonizable crept into its meaning. And this connotation may possibly be misleading, to a greater or less extent. Let me tell you a story in this connection. One day Georges Duhamel was received by Mussolini, and in the course of the conversation the dictator told the writer of his high regard for spiritual values, of course, and especially for the spiritual discipline of the Church and for her *saints*. And he went on to say: "What moral strength and inspiration a man must receive when, getting up each morning he says to himself: Be good, my boy, one day you will be canonized!" This was a typical Mussolinian interpretation of the glories of canonization. But it shows to what degree these glories are able to alter accidentally the simple meaning of *sainthood*.

The fact is that *not* all saints are canonized or canonizable, but only those endowed with such poise and heroism that they can be offered as beacons to mankind. I am ready to

admit that artists and novelists who had the same concept of sainthood as Mussolini's would be disappointed in their ambition. If there are no or exceedingly few canonized artists, there must be good reasons for this; moreover artists cannot have everything, and they are already beacons for mankind in relation to quite other shores and other high seas. The kind of sainthood to which they can aspire is not, I think, of the canonizable type—but rather of the type pointed to by Kierkegaard when he imagined sainthood in the shape of the most ordinary, unrecognizable man, *Disguised in life's most hodden-grey,/ By the most beaten road of everyday*, as Francis Thompson said of the poet's vision.[1]

How, then, can we get rid of the parasitical connotations I have mentioned? I would suggest that for the clarity of our discussion we simply leave aside the word *sainthood*, and that instead of saying: "one would have to be a saint"—moreover the question in such matters is not *to be*, but to be *on the way*—we simply say: "one would have to strive after perfection." It is enough, it seems to me, to say *perfection of life*, though for other reasons this expression may also seem unsatisfactory in some respects.

Let us introduce, furthermore, an auxiliary concept, closely related to that of *state of life*, may I be allowed to say the concept of the *occupational stream*. This concept, as I see it, refers to the typical conditions, both external and psychological, involved in a certain state of life or a certain

[1] In "Sister Songs," *Works*, vol. I, p. 53.

vocation, in relation to moral progress and the perfection of human life.

A monk has given up everything to enter a state of life dedicated in itself to the pursuit of perfection. I would say that whatever his personal behavior may be, the *occupational stream* in which he is engaged runs in the direction of the perfection of human life.

And I would say that in the scale of the states of life which have to do with the spirit, the *occupational stream* of the artist is at the opposite extreme of that of the monk. The state of life of the artist is in itself dedicated to the world and the beauty and mystery and glory of the world. For the reasons I have outlined, and doubtless many others, his *occupational stream* runs, I think we must admit, in a direction contrary to or estranged from the perfection of human life.

But this means in no way that the artist is necessarily carried along in the same direction. When it is a question of Man, any external and psychological conditioning makes sense only with reference to the freedom of individuals, which no stream can force. Streams can be *swum against;* they were even made to be swum against, and all of us would be lost if we were unable to swim up-stream. Even a monk, if he does not have to swim against his occupational stream, at least has to swim faster than the stream.

If the artist has to struggle against a particularly strong occupational stream, he also has particularly strong assistance: I mean to say those *aesthetic virtues* of which I spoke in the first part of this chapter, and that *poetic experience,*

which of themselves, despite the difference in nature, are congenial with the virtues and experience of the saints, and tend to prepare the artist, if he wants, for the superior achievements of moral and spiritual life.

In contrast to Gide's famous statement, let me read a passage from Francis Thompson's Essay on Shelley:[1] "The devil can do many things," Francis Thompson says. "But the devil cannot write poetry. He may mar a poet, but he cannot make a poet. Among all the temptations wherewith he tempted St. Anthony, though we have often seen it stated that he howled, we have never seen it stated that he sang."

5.

At this point we are able, I think, to grapple with the three arguments, which I mentioned some moments ago, of those who claim that no hope is left to the artist except to serve Mammon.

In the first place, we may observe that the perfection of human life does not consist in a kind of athleticism of man-made virtue, and does not depend only on the effort of Reason. According to the views of Thomas Aquinas I mentioned earlier, the perfection of human life might be described as a certain fulness in the freedom of divine love to expand in a human soul and do there as it pleases. Everything, then, finally boils down to a relationship of person to person between the uncreated self and the human self, and to the fact of a man loving always more—and, each time

[1] "Essay on Shelley," *Works*, vol. III, p. 33.

he fails, loving still more. What is demanded of us men is not to *have reached*, but ceaselessly to *tend*. And who could claim that the road is not open to the artist as well as to his equally weak fellow-men? His vulnerability to the arrows of the senses makes him vulnerable also to more spiritual arrows. If it were a question of becoming an impeccable Stoic sage, he—and everyone—could only throw in the sponge. But it is a question of growing in love in spite of peccability. The perseverance of a Max Jacob in starting again every day the story of the Penitent Thief, prepared him to accept the supreme sacrifice with saintly sweetness, and to die as a wounded lamb.

Neither the senses, moreover, nor the delights of the intelligence-permeated sense are impure in themselves. In dealing with them the heart of man can always endeavor not to be bewitched by them, and grope after its own purity. If the poet is torn between passivity to irrational inspiration and sagacity of working reason, this is but a sign that he needs more than anybody else that unifying contemplative repose of which his experience as a poet is an ambiguous image. If he is busy with the world and its mysteries, this is but a token that his love may offer the world to his God as his work offers it to men.

In the second place, it is, we must say, a childish notion to think that a novelist or a playwright, in order to know that of which he speaks, needs to steep himself in the sins of men and to hunt after some personal experience of the various kinds of troubles and diseases his characters will

suffer. It is enough for him, to be sure, to look at his own inner universe of repressed tendencies, and at the various monsters which are latent in his heart. Introspection, more than any poor and always limited experience of sin, is the best teacher in the geography of evil.

Finally, that knowledge through inclination or congeniality by means of which a novelist knows his characters, is, as is every kind of knowledge, spiritual in nature and *intentional*, as the Schoolmen put it: that is to say, it causes the thing known to be present in the knower immaterially, without any real mixing-up of the being of the one with the being of the other. The kind of inner mimicry of his characters which is peculiar to a writer tends of itself only to foster creative intuition. Deep as this inner mimicry may be, it remains by nature an instrument for immaterial knowledge, it does not involve or entail of itself any insidious complicity or connivance with, or any participation or delectation of the heart in the depravity of the imaginary creatures which are the children of the author's mind.

Let us consider that one of Dostoievsky's characters who most resembles his own confession, Stavrogin of *The Possessed*. Dostoievsky "contrives no alibi in behalf of him, he leads him to his miserable suicide with a severity, a clear-sightedness, a logic without pity. He loves him, however, for it is himself, or at least the dark face of himself. But it is exactly here that best appears, to my mind, the transcendence of Dostoievsky's genius as a novelist. His work is similar to the living universe, there is in it a sort of *metaphysical pathos* because the beings who move about in it

are,—to a particularly high degree—in the same relation to the thought that creates them, as men are to God. He loves his characters, more tenderly perhaps than does any other artist, he puts himself into them more than does any other; at the same time, he scrutinizes them and judges them inflexibly."[1]

It may happen, to be sure, that in the process the intentional union by knowledge shifts to some union by real influence, and that the character contaminates, as it were, the author, awakening in him, in actual existence, and in the manner of some involuntary movement or inclination, the same fire with which this character is burning. Similarly a good actor always undergoes to some extent in his own being the hold of the character whom he incarnates on the stage. All that, however, is but accident, and more often than not pertains only to the temptations which are inevitably linked with the exercise of any kind of vocation.

Thinking of certain pages in the early volumes of Julian Green's admirable Diary, I wonder whether some of the artists who are most concerned with this problem, and seem to believe that they are really accomplices of their characters, are not victims of the old Lutheran illusion, which considered any disordered movement or storm of the sensibility—very strong perhaps but involuntary and not consented to—to be a sin.

Let me add that the highest form of knowledge through inclination or congeniality is provided by that kind of presence of the one within the other which is proper to love. If the novelist is the God of his characters, why could he not

[1] "Dialogues," in my book *Art and Poetry*, p. 59.

love them with a redeeming love? We are told (it is irrational, but it is a fact), that Bernanos could not help *praying for his characters.* When a novelist has this kind of love even for his most hateful characters, then he knows them, through inclination, in the truest possible way, and the risk of being contaminated by them still exists for him, I think, but to a lesser degree than ever.

6.

I have said again and again that Beauty and Poetry are an inexorable absolute which requires a total gift of oneself and which suffers no division. Only with God can a man give himself totally *twice at the same time*, first to his God and second to something which is a reflection of his God.

When the love on which the perfection of human life depends, and which tends to the self-subsisting Absolute, is integrated in the creative source itself, it brings no division in creative activity, because it penetrates and activates everything, and the very love of an artist for the particular absolute he serves.

The most defective comparisons are sometimes the most instructive. It is well known that up to a few years before his death Utrillo was mad for drink. One of his biographers tells us: *he painted only to drink.*[1] And what admirable paintings he painted!

The merely physical passion of drinking is simple enough

[1] Francis Carco, *La Légende et la vie d'Utrillo*, Paris, Grasset, 1928, p. 29.

to incite a painter without introducing in his art any extraneous element.

At the other extreme, the transcendence of the supreme love, which makes this love nowhere extraneous, enables it, when it quickens the creative source, and animates the virtue of art from within, to do so in a superior, infinitely delicate manner, and without any of the risks which human motivations may involve of bending or blurring this virtue.

If a painter, intoxicated with another wine than that of our vineyards, *paints only to please God*, he can be a good or a bad painter, and he does not become a better painter by the very fact, but he is put in a position to use his virtue of art in the purest and freest manner.

For all that I think that the condition of the poet, which obliges him to swim up-stream if he wants to advance toward the perfection of human life, places his mind in a particular sort of obscurity as to his awareness of this very advance. I imagine that any poet or artist who has long striven toward the true end of human life will probably say with Léon Bloy: "I could have become a saint, a worker of wonders. I have become a man of letters,"[1] at the very moment when his soul is most deeply transformed by love.

[1] "Au Seuil de l'Apocalypse" (*Pilgrim of the Absolute*, p. 293).

Index of Proper Names

Index of Proper Names